The Pieces of Me: The Anna Frazier Story

Acknowledgements

I would like to thank Anna Frazier for listening to the voice of God and allowing me inside her life. Her story is truly and anointed and courageous one. I thank her family for allowing me into their lives as well. This journey has been a trying one for her as the subject of this novel and for me as the one to personify not just the events, but the emotions displayed throughout her life.

It has been and honor to be a part of a project that gives God all the Glory, despite the destruction that Satan attempted.

The events of this story are based on one woman's real life experiences. Names have been changed to protect the identity of the guilty and innocent.

Chapter One
The Ballroom Theatre
(Introduction)

I watch the people and the cars carousel around me as I ride in the back of the Lincoln Town Car, on my way to the Hilton at Biscayne Bay Hotel, in downtown Miami.

I still can't believe that my adversity did not put a stronghold on my life. Well it did for a time, but I'm still alive. My story is one that most wouldn't believe and others would simply mock. But the reality is, I am an extraordinary individual. And my life has been pretty far from ordinary too.

Just as my mind tries to recall a time when I wasn't in pain, physically, mentally, or emotionally, I hear a light squeal of the brakes as we pull in front of the elegant establishment. I take note of the mirrored windows and immaculate construction.

"Right this way Ma'am." The polite doorman says, opening my door before my chauffer even has a chance to exit the driver's seat.

"Thank you, but I'll wait for my driver." I try not to be rude to the man as I reject his kindness.

My life is a true testament that trust is not to be taken lightly, and my first thought, "How does he even know who I am?" Only triggers the natural barrier I have guarded myself with for so long.

"I'm sorry for keeping you waiting, Anna." My chauffer, Fred, apologizes as he escorts me toward the entrance of the Hotel.

"No worries, just make sure they have my bags in my room by the time I'm done please." I request.

I rely on Fred for making sure details like this are handled ever since my sudden success. Fred, is my baby sister Torie's husband. She and Fred are two of the only people I truly trust in this world. Which is why along with making Fred my trusted side kick, Torie, is my personal assistant.

"Torie should already have us all checked in." I tell him.

We enter the lobby of the Hotel and the first thing I see is a poster announcing the time and destination that my seminar is taking place. It's still difficult to see and hear my name and face on such a large scale. I've gone from broken house wife to motivational speaker in what seems like overnight.

I must admit that positive attention is much more esteem-boosting than the attention I've become accustomed to from the past. Just the thought that people actually come to listen to what I have to say, continues to remind me that there is a reason for my struggle and it is up to me to fulfill that destiny.

Something about today is different. I feel a sense of peace that I have struggled to find for a while now. I have been broken and the pieces of me are finding their way back to one another. Everything I've gone through is beginning to make sense and have purpose beyond the torture I've experienced.

"Ms. Frazier?" The well-dressed man that I assume is the event coordinator, approaches us with his hand extended. "Good morning, my name is Carlton. I believe I've been in contact with your assistant, Torie Johnson." He looks at what appears to be an invoice with handwritten notes on it, as he speaks.

"Good morning Carlton." I reciprocate his gesture. "Where should I set up?" I ask.

"Well Ms. Frazier, there has been a slight change of venue. You were scheduled to occupy the Ballroom, but as we began to sell more tickets, my manger made an executive decision to move your seminar to our performance theatre. It will more than accommodate your needs.

"Performance theatre; won't that be too large for my event?" I still have an issue with too much change.

"Well, Ms. Frazier", the man continues to examine the invoice even closer. "It appears that the seminar has sold more than four times the advance tickets than expected. So you see Ma'am, we were forced to move your event . . . or stop selling tickets."

Fred and I look at one another in astonishment.

"May I please see the theatre?" I ask.

"Right this way."

We follow the slim, blonde-haired, blue-eyed gentleman through the corridor that gets even more beautiful the closer we get to our destination. When we reach the door, I am amazed by the intricate details of the entrance alone.

The distinctive carvings, along with paintings of angels and celestial representations of life seem to brighten my spirit and give me a different perspective on the change that is taking place. The enormous room draped in gold paint, elegant draperies, and large crystal chandeliers, appear to be able to seat at least 2,000 people easily. Just the thought of filled seats and that many pair of eyes and ears giving me their undivided attention, causes anxiety fueled by excitement. I have never spoken to an audience of this size before. To be honest, I've never imagined that I ever would either.

Again, a sense of purpose washes over me as I envision a theatre full of attendees on the edge of their seats.

"I'll go get your materials." Fred announces.

"No." I say staring whimsically out into the empty seats." I won't be needing any materials today, Fredrick."

I can feel him burning a whole in the side of my face with his eyes. I am not a creature that is prone to change, and everyone in my life knows this. So the mention of doing something "out of the norm", for me is not just unheard of, it is yet another breakthrough.

Fred moves to my side.

"Are you sure?" He asks, completely aware of the things that 'change' has triggered in the past.

I finally take my eyes off the theatre and I look him directly in the eyes.

"I'm positive, God's got this little brother."

2 Hours later

As I sit in awe of my new seminar location, the time passes at a rapid speed, and two hours have passed without me even noticing. The first indication of the time is the group of about twelve women that arrive first to find their seats. I look at my watch. "One forty-five" I mouth to myself.

I step back from the podium and I look around the room. I begin to feel as small as an ant in an empty swimming pool. I can hear my heart pounding like an erratic drum in my ears and my palms are sweating.

"Fred." My short breaths barely allow me to say his name.

"Did you call me, Anna?" He says running from backstage.

"I need water." I gasp.

Noticing my pattern of breathing and the beads of sweat forming on my face, Fred quickly runs to my side.

"You know you don't have to do this, right?" He says.

"Yes I do. Just get me some water." I say with commanding eyes.

"You're the boss."

"I rebuke you Satan, in the name of Jesus." I say while taking deep cleansing breaths.

An instant calm washes over me, and when Fred returns with the water, I am perfectly fine. I walk to my dressing room and I splash cold water on my face. When I stand, I see my reflection in the mirror and the person looking back at me is not the woman I was a year ago.

"Ms. Frazier . . . it's time." Carlton says with a light tap on the door.

Taking another long deep breath seems to cleanse my soul and open my once broken spirit.

"Here goes nothing." I say aloud to myself.

When I walk on stage, the room is almost full to capacity. The scattered chatter, silences slowly as my presence is noticed by the audience. I hear a single hand clap as I see my beautiful little sister Torie standing in the front row; she has always been my cheering section. The clap quickly turns to a round of applause from the audience greeting me as I approach the podium. I smile and wait for the applause to subside before speaking.

"I would like to thank everyone for your attendance today and I promise you will leave here with so much more than you came with. Had I known we'd have all this," I say referring to the large theatre. "I would have bought a band." I joke.

The attentive audience chuckles momentarily and waits for me to continue.

"I know my seminar is known for the interaction and visual stimulants, but today is different. I want to take you all on the journey that has brought me to where I am today, in an effort to change the lives of anyone under the sound of my voice. And just as importantly, anyone under the sound of yours.

In order to motivate others, I had to be delivered from a very dark place. I had to be living proof that everything I talk about is possible; possible for me, possible for you, possible for anyone. I want people to know; no, I need people to know that not only is there light at the end of the tunnel, but there is life after darkness.

My name is Anna Frazier, and this is my life."

Chapter Two
The Stolen Piece
(Floyd)

I was born February 9th 1981 in St. Louis Missouri, and I was the first in my family born to my generation. According to everyone older than me in the family, I was an exceptional child. So exceptional in fact, that I started speaking in complete sentences by the time I was seven months old, confirming the doctor's observation that I was a special baby and far too attentive at birth; looking around and smiling in the first moments of my life.

The story was, my mother and her oldest sister, Rita, took me to a scary movie. Then as the lights dimmed and the noise rang through the theater, I turned to my unsuspecting mother and said, "Momma, I'm scared." The fact that I was speaking a whole sentence was one thing, but the fact that I knew the words to express my feelings, was another. I had apparently been holding out.

My aunt didn't believe it until I spoke to her as well. They were so outdone, they left the movies and took me straight to my Grandma Lily. Which now as an adult, I wonder why she never asked them why they would take a baby to a scary movie in the first place. Anyway, that day my grandmother said that I was special and God had a plan for me. I'm sure at the time she was completely oblivious to how true her statement was.

From that point on, I was the neighborhood and family spectacle. People would come specifically to see me, "the talking baby". Even relatives from out of town would come into town just to see me. By the time I was a year old, I was walking, talking, and fully potty trained. It was about that time that I started to recall some of the details of my childhood.

It's amazing how even as a child things can make adult sense. I can remember my mother, Trina, soaking up all the attention that came from having a baby with my intelligence. She even starved for attention from those that would otherwise turn down their nose to her. But I know now that her need for attention came from a much deeper place; a lonely place. Even then, I could see the unexplained sadness in my mother's eyes. I still wonder how much of that sadness came from the unwanted absence of my father, Curtis.

Between the ages of one and five I experienced more emotions than one child should be allowed. I went from the super special "talking baby" to "Momma's big girl". And during the same time, I watched my mother go from a beautiful woman that could have had any man she wanted, (except for my father) to an alcoholic, drug addicted, battered woman. To a child my age it seemed like all I did was blink and everything had changed. By the time I was five, any joyful memories were just that, memories.

After chasing my father until even she became ashamed of herself, my mother settled for an ex-amateur football player named, Floyd. By the time he met my mother, his title had been reduced to crack head. Actually, before she got pregnant with my little sister, Leah, and she and Floyd got married, he was one of the nicest men I had ever met. My father's absence made it hard for me to remember his face at times, so I thought Floyd was an ample substitute. That is, until he realized that my mother was using me to get attention from my dad whenever she could; which wasn't often.

Just thinking back to that time makes me realize the selfishness that even a child can possess when I ignored the cries of my mother all because he was nice to me; I loved Floyd. But I will never forget the day all of that changed. Somehow, Floyd got word that my mom started sneaking around with me, to meet up with my dad. Even I could tell their meetings were not about me.

The moment we walked in the house, my step-dad was visibly furious.

"Where the fuck you been?" He questioned. "You been to see that nigga? Anna, take yo' ass in the back!" He yelled.

I quietly crept down the hallway to my room, and just as I reached the room, I heard the first slap. I did all I could to not visualize what was happening to my mother in the other room. With every slap, punch, and kick, he would call her the most vulgar names between her screams, ranging from bitch to cunt. I even had to listen as he violently raped my mother after beating her into submission. I was only three-and-a-half years old and my love for Floyd instantly turned to hate, and my mother was turned into a victim that same day; I wanted him to die.

His drug problem coupled with his jealousy only made him a monster and a force to be reckoned with. My biological father felt it was best for my mom and her marriage if he just left the picture for good. But no one seemed to consider what was best for me; they only thought about themselves. Because I was so young, I blamed Floyd instead of placing blame where it belonged; my mother and father.

Things only got worse from there and something in my mother broke even more than before. My life became a waking nightmare. For the next few years my mother became his whore and personal punching bag; literally. We were prisoners and Floyd was the sadistic warden.

While enduring beatings and being forced to prostitute to supply their drug habit, my mother was also dealing with the fact that my Grandma Lily was terminally ill and her body was slowly shutting down. It seemed her only refuge was absence; whether it was her not being there physically or her being so high out of her mind, that her physical presence was irrelevant. Then, there was the time when I felt that I was a sacrifice for my mother's temporary release.

It wasn't until "it" happened, that I understood the conversation my mom had with me before she left me, for three days. I was only five-years-old but something felt terribly wrong. When I close my eyes today, I can still see her face as she got down on her knees, looked me eye to eye, and spoke.

"Hey baby, you momma's big girl right?"

I nodded my head completely unaware of what was happening.

"Well, I need you to be a big girl and stay here with Mr. Floyd while I take care of some business. I want you to be good, okay?"

I nodded my head again. But that time I noticed something in her eyes. I know now that what I saw was desperation.

"Why can't I go with you, Momma?" I asked.

"Because you can't!" She snapped. "You and Leah have to stay here."

Her demeanor changed instantly with those three words. I regretted asking the question, because upsetting her only made her walk out the door without a hug, a kiss, or even a second look. The door had barely closed before I began to cry to myself.

"Shut yo' little ass up, or go in the other room with that bullshit!" Floyd wasted no time showing his true colors. "I got something you can put in your mouth." I heard him say right before I entered my bedroom.

Even as intelligent as I was, at only five-years-old I had no idea what he meant. So after watching my share of cartoons and Sesame Street, I couldn't help but wonder what, Mr. Floyd, could possibly have for me. I slowly walked down the hall and made sure my face was completely dry so he wouldn't be mad at me anymore. I peeked around the corner at my three-year-old sister sitting on the floor with a plate of food. I still can't understand how a mother could leave her children with a man that treated her the way he did; biological or not.

"Mr. Floyd, can I have something to eat?" I asked in a timid voice.

The look he gave me was so sinister, I still remember the chill I felt like it was yesterday.

"Whatchu gone give me, whore? Whores don't eat for free." He told me.

"But I'm hungry. Why Leah get to eat and I can't have none?" My young mind was trying to comprehend his logic.

"See that's you're problem now, yo' mouth too mutha fuckin' smart!" He yelled while getting up out of the chair.

I think I saw him for the first time that day. The man I once loved. The man I wished could be my new Daddy. Life seemed to move in slow motion for a few seconds as I watched this large, dark-skinned man, with flared nostrils and hate in his eyes tower over me.

"Come here!" He snatched my arm almost completely out of the socket.

I could hardly stay on my feet as he burrowed down the hallway, pulling me behind him.

"Stay in here!" He ordered Leah.

She seemed to be as afraid as I was when my eyes pleaded with hers in my last seconds in the living room. He took me straight to the bedroom that he shared with my mother. The moment we entered the room, he threw me against the wall.

"But I didn't do nothin'!" I cried out in fear of getting a whoopin'.

But the violent slap to my face let me know that he didn't care what I said.

"Shut the fuck up! I got something for that smart ass mouth!"

I couldn't understand what was happening. I didn't know what I did so wrong to deserve his treatment. I remember wondering why a man his size would hit me so hard; it felt like hatred.

When I saw him loosen his belt I just knew this was it, he was going to beat me like he did my mother. So when he stood in front of me and began to slap me in the face I was confused. But that time the slaps weren't as forceful and it didn't feel like his hand.

I finally got a look at the object hitting my face and it literally looked like a brown, one-eye, snake. Having never seen male genitalia, I was clueless at the time that this pervert was hitting me in the face with is uncircumcised penis. I felt something wasn't right, but before I could protest he put himself into my mouth.

"If you bite me, I'm a fuck you up." He said giving me threatening direct eye contact.

The fact that I was just a little girl didn't matter to him, and my constant vomiting while he forced himself down my throat, seemed to matter even less. I tried to cry, but all I could get out were tears.

During my ordeal, all I could think to myself was,

"Why is he doing this to me?"

"What kind of punishment is this?"

"I can't wait for this to be over."

"Where is my Momma? Is she ever coming back?"

"I got to protect Leah."

While all of the thoughts of a confused five-year-old raced through my mind, the man that my mother decided to marry, the man she trusted with my innocence, was ejaculating in my face.

"Go wash yo' face." He said after he released a sigh of perverted satisfaction.

I went straight into the bathroom and to the sink. I washed the thick sticky substance off my face, then looked in the mirror. Again, I wanted to cry but I couldn't; I was too mad.

The next day, I sat in my room playing with my little sister, trying to enjoy what was left of my joy and innocence.

"Anna!" My heart dropped when I heard his voice call my name.

Momma still wasn't home and I didn't want him to make me throw-up again.

"Anna!" He yelled again, but that time with anger in his voice.

I quickly ordered Leah to get in the closet and stay there until I came back to get her. When I walked in the hallway, I saw him sitting on the bed in him and my mother's room.

"Come here." He said.

I slowly approached the door and I instantly felt the urge to vomit, but I didn't.

"Yes sir." I said, but I refused to enter the room.

"Come sit on the bed." He patted the bed to coerce me to sit next to him.

With my eyes to the floor, I slowly made my way to the bed and I sat next to him like he told me. I could feel him looking down at me, but I refused to make eye contact with him.

"Aye." He said.

I finally looked up at him with watery eyes.

"I ain't gone do that to you again." He told me.

My whole body relaxed from the inside out, and at that moment I let my guard down. But before I had a chance to exhale a sigh of relief, he was forcing his hand into my shorts and in between my legs.

"Lay down." He said.

"But I . . ."

"Lay down!" His voice turned mean again.

As my back hit the bed, I couldn't even begin to imagine what he was going to do to me. When I felt him pulling my shorts and panties down, I tensed my entire body.

"Open your legs. I'm not gone hurt you." He lied.

I relaxed my legs just enough to allow him to pull the garments off my feet. When he pushed my legs apart, I closed my eyes as tight as I could. What happened next was equally confusing as it was disgusting; he put his mouth on my virgin vagina. It hurt, like he was biting me with tiny teeth.

The musty smell in the room was worse than anything I had smelled before in my young life. I'm still not sure if it was the smell of my privates secreting juices it was not meant to at my age, or the stench of Floyd masturbating while he violated me.

After a few more minutes of confusion, there was a sudden gush of fluid pouring out of me and I was afraid that Floyd would get angry with me for peeing in their bed. But when I tried to sit up to see the damage I had done, he pushed me back down.

"Wait a minute; stay right there." He commanded.

I wanted to scream as loud as my five-year-old lungs would allow. But who would hear me? "Where is my Momma?" I thought.

He returned minutes later with a toilet plunger, and I could do nothing but watch as he proceeded to penetrate me with the handle of the plunger. It hurt more than any pain I had ever felt. I was hurting inside and out. Even at five-years-old I knew I didn't want to relinquish my power to him, so even when I saw the blood soaked sheet, I still refused to cry.

"Get up and go clean yourself up." He told me.

I tried not to cringe as I slid off the bed, then picked up my shorts and panties. Just as I reached the doorway, Floyd hit me with a reality I refused to believe as he pulled the linen off the bed to dispose of it.

"Aye, you can tell if you want to; I don't care. Ain't nobody gone believe you anyway."

Later that day

After getting Leah out of the closet, I spent the rest of the day in my room. I wouldn't even go out to eat. My plan was to wait until Floyd fell asleep, sneak in the kitchen, get some food, and eat under the bed like I did the night before.

When Leah left the room to go eat, I kept the bedroom door open as if it protected her somehow. But when she came back, I'd close it tight with regrets of not having a lock on the door.

I can't describe the feeling I felt when I heard my mother's voice in the living room. Leah must've heard Momma at the same time I did, because we made eye contact before we both jumped up and ran toward the door.

"Momma!" We screamed simultaneously as we ran down the hall.

She scooped Leah up in her arms as I wrapped my arms around Momma's waist.

"Quit acting like y'all missed me." She said looking in my step-father's direction.

"I'm missing my money. You got my money?" He asked as if to reply to her indirect comment.

Momma just ignored him and walked to her bedroom. I followed closely behind her trying to get her attention. She shuffled around her room preparing to take a bath. I waited until she had no choice but to listen and I followed her into the bathroom. Just as she was completely submerged in water, I approached her.

"Momma, you can't leave me here by myself with Mr. Floyd no more." I tell her.

"Girl, don't start that." She was dismissive.

So I did what I thought was the right thing to do; I pulled down my panties and showed my mother my tampered with vagina. I wasn't aware of the damage from the wood and splinters, but it was visibly obvious that something was being done to me.

"See, you was probably being fast. Don't nobody want yo' ass anyway. You always tryna mess it up for me. Go sit yo' grown ass down and stay outta grown men's face!"

It was at that moment that I knew Mr. Floyd was right. She wouldn't believe me, because she didn't want to. I wanted to believe it was the drugs and alcohol that distorted her views of reality. But I believed whole-heartedly that my mother sacrificed my innocence so she could have a piece of a man. I supposed, if my existence couldn't get her the man she wanted, then it would allow her to keep the piece of man she had.

When I left the bathroom that day, I became a different child and I knew my life would not be the same as other children. That was the beginning of my life, and the first piece that was stolen from it.

Chapter Three
The Broken Piece
(Pat)

After my Grandma Lily passed away, I was convinced that the only someone in this world that truly loved and protected me, was gone forever. I was left here alone, with a mother that cared more about men, money, and drugs than she ever cared about being a mother; in a rat and roach infested apartment. But no matter what she did, no matter how many times she left me alone to be beat and violated, no matter how neglected I was, I still loved my mother more than anything in this world. I mean, it was Floyd's fault that she treated me that way, right?

It seemed like soon after my Grandma became ill, Floyd began to transform into the creature that my every nightmare was made of. Then after she died and I thought things couldn't get any worse, but *he* did. He didn't beat or molest my little sister, Leah, *his* child. But what he did was use her to abuse me mentally; which in turn, damaged her in a totally different way. He beat and raped my mother worse and more often than before. And when he sent her out to walk the streets at night, he would have his way with me.

Almost every night it was the same thing; I would hide my little sister in the closet and then go to my mother's room to satisfy Floyd's sick fetish. The fact that he could be attracted to a child, was sick within itself. But it seemed, the fact that I was small and totally the opposite of a woman, with no curves or body fat whatsoever for that matter, made him even more attracted to me. There were even times when he would give me alcohol to make me more relaxed and compliant. So after a few years of physical, sexual, psychological, and mental abuse, I developed a coping mechanism. I would just go somewhere else in my head until it was all over. And it worked; at least I thought it did.

But the day I saw a glimpse of light at the end of the tunnel was the day my baby sister, Torie, came home from the hospital. I was only seven-years-old at the time, but I felt like a proud parent. She was beautiful, and no one seemed to notice that she was not exactly 100% Black. I guess Floyd had already prepared himself for the possibility that Torie wasn't his, especially considering all the men he forced . . . allowed my mother to sleep with. Either way, it was completely dysfunctional.

Torie and I were the light-skinned children of the three, but Leah had a beautiful caramel complexion and she was almost as big as me, although I was three years older than her. I'm not sure if it was malnourishment or genetics. Anyway, when I saw Torie, I had never seen such a pretty baby in my life. She was extremely light, with bluish-gray eyes that seemed to change color with the wind, and her hair was a golden-blond color. And from the first moment I laid eyes on her, I knew I had to protect her from Floyd.

Then one day, after Momma was gone for a day or so, she came home and Floyd was immediately ready to pounce.

"Baby, go run momma some bath water." She said without even greeting either of her three children.

"I don't know what you takin' a bath for, cause if you ain't got my money, you finna take yo' ass back out there!" Floyd told her.

Momma looked tired, like an old man working in a factory.

"I'm tired Floyd; I'll go back out later." She said continuing to take off her shoes.

"What the fuck you say to me? You go, when I tell you to go!" He growled.

He used to wait until we were in another room to strike my mother, but not today.

Smack!!

He slapped her so hard she fell off the couch and onto the floor. I instinctively grabbed two-month-old Torie off the couch and told Leah to come with me. We were so used to the abuse by this point, that neither I nor Leah had much of a reaction. We just closed the door, turned up the TV, and I prayed that Floyd didn't kill my mother.

As if it was all a part of her beating, the torture was concluded as always with a brutal rape. Her screams sounded as tired as she looked. So it shocked me when she woke me up in the middle of the night.

"Anna!" She whispered loudly, trying to wake me up. "Help me."

"What's wrong Momma?" I asked with the innocence of a child willing to do whatever her mother asked of her.

"Here." She gave me keys and the backpack that I never used, because I refused to leave my sisters alone. "Hide these and pack up as much of you all's stuff as you can. Be quiet and hide the bag when you're done." She instructed.

The very next night after Floyd fell asleep, high out of his mind, Momma woke us up and we ran. I supposed running would have been a wonderful thing if we hadn't run straight to a crack house.

My mother made arrangements with her friend, Pat, for us to stay with her for a while. The problem was, Pat was as much of a junkie as my mother, and her house served as a part-time dope house, with as many rats and roaches as we had. But at Pat's, we slept on the floor.

When we showed up, Momma stuck around for all of five minutes. She left me there alone in a crack-house to care for two young children, at only seven-years-old.

It wasn't long before some older boys made their way to the room where my sisters and I were sleeping. I imagined they had to be about sixteen or seventeen; teenage dope boys. The minute I woke up and saw an unidentified males in the room, I screamed to the top of my lungs.

"What's wrong baby?" Pat said running in the room.

I pointed to the boys.

"Tell them to get out." I said rocking my infant sister back to sleep.

"Y'all, get y'all asses outta here with these girls!" She yelled.

All of the boys turned to leave accept for one. He leaned over and whispered something in her ear while penetrating my eyes with his. When he finished, he turned and left the room as well.

"Chile, put that baby down; she gone be fine. But I need you to come with me and I'll make sure they safe."

I could see the same wanting look in her yellow eyes that my momma had before she left us there.

"Come with you for what?" I asked.

She looked over at my sleeping sisters.

"Yo' momma say you take real good care of them girls." She said smiling.

I looked back at my sisters, but when I turned back to look at Pat, her smile was gone.

"If you want them to stay safe, you need to come with me." She said giving the silent ultimatum.

I slowly got off the floor and reluctantly headed to the door. As we made our way to a different room in the house, Pat began to converse with me, but our conversation was far from casual.

"Do you remember me?" She asked.

"No." I said with my eyes to the floor.

"Well, I remember you. I remember when you was just a baby. I'm like your auntie; just call me Tee Tee Pat." She was smiling again. "Now yo' momma told me you was a big girl and if I needed help with anything you would do what I asked."

The title "big girl" was becoming a curse and not at all the privilege I thought it would be.

We entered the living room full of male and female addicts, and a few dealers sprinkled around the room.

"You see him?" She asked me, pointing to the boy that whispered to her earlier.

I nodded. Then she turned to look at me with her hands on my shoulders.

"See baby, Tee Tee Pat is sick and if you nice to that boy for me he'll give me my medicine; he ain't that much older than you." She tried to convince me.

This felt all too familiar and I wanted to scream "Noooo!!", but all I thought about was what would happen to "my babies" if I didn't do what she asked. I looked at the teenage dope dealer, with the evil smirk that reminded me that I was as useless to him as the dope fiends her serviced. Then I looked back up at Pat.

"Go on girl, he like you." She lied.

I walked in his direction with wobbly legs and my heart pounding so loud and hard I barely heard the boy tell me to dance. I began to dance to the booty popping music playing in the background, and then he gave his next request.

"Take off yo' clothes." He ordered.

I looked around the room full of perverts and women that cared less about me than they did themselves, and I began to remove my clothing. The older boy's eyes lit up when I started to expose my seven-year-old body that was void of maturity or curves of any kind. I continued to dance like he told me, all while praying that my little sisters were still asleep and unaware of the debauchery taking place around them.

"Come here." The boy giving the orders said.

He was a caramel colored boy with thick eyebrows and dark eyes. His eyes were what I remembered the most. The dope boy necklace and baggy clothing with crisp creases ironed in them was a clear indication of his profession.

I walked over and stood in front of him without a word. As I stood there I couldn't understand what anyone could possibly want from me and why I was being victimized, once again. But before I could finish my thought, he was unbuckling his belt and pulling out his privates.

"Here, suck on this till I tell you to stop." He said as if I had no choice in the matter; and I didn't.

I would endure this abuse if it meant that "my babies" would be safe. So I did exactly what he said. He never told me to stop, but there was no need after he released himself in my face.

"Somebody could make some good money off that mouth." He said laughing to another one of the boys. "You should get in on this, Dog."

I wanted to cry on the inside at the thought of what was about to happen to me. But I didn't, I did what I always did; I went somewhere else in my head until the last pervert was orally satisfied. When they were done, I collected my clothing and started toward the room where my sisters slept. On my way out of the room I felt a hand on my shoulder; it was Pat.

"You was a good girl, Anna. Yo' momma lucky to have a daughter that got her back."

I walked away without saying a word, and a single tear escaped my eye and ran down my sticky cheek. I finally made it back to my sisters after washing the shame off my face. Laying there, wishing I could fall asleep, but I couldn't for fear of someone or something coming for us. All I could think about were the words that Pat said to me.

"Yo' momma said you was a "big girl". She lucky to have a daughter that got her back."

That was the day that the reality of my mother being my first pimp set in, and I broke. I couldn't trust anyone, not even my mother.

I was only seven-years-old.

Chapter Four
The Missing Piece
(Curtis)

At one point in my life, right before Floyd started to have his way with me, I could see things; not normal things. I actually had a spiritual connection. That connection seemed to sever at Floyd's first touch, but I could never forget it.

I used to see what appeared to be angels fighting all around me; a spiritual war so-to-speak. I knew things that were untold to me, before they took place. And even as young as I was at the time, it all made perfect sense to me. Thinking back to those memories makes me wonder the fate of my future before the abuse.

But as I question the possibility of what could have been, I can't help but wonder how the true presence of my father may have impacted my life. He was in and out, never a constant. I used to think it was because of Floyd. But over the years, through life's experience and sheer observation, I realized that the reason for my father's absence was all his own.

He liked to make it seem like he was around, so he would pick me up from time to time and take me to the park. Once we were there, he would take pictures of me in between flirting with random women. Even now, when looking back over the pictures; they are blurry and unfocused due to the partial attention he paid me.

Then after he was done taking pictures as proof of his faux fatherhood, he'd take me back to the hell I knew as home. I often contemplated telling him about what was happening to me, but I was afraid; afraid that his reaction would be as dismissive as my mother's. And if I did tell him, what would he do? Where would he take me? Even as a young child rejection was a very present force in my life.

I found out the hard way that my father was even more unfit to be a parent than my mother. When I was seven, one of my dad's sisters passed away. She was technically my aunt, of course, but I had never laid eyes on her in my life.

The story was, my paternal grandfather, Joe, was an extremely abusive man, so my grandmother, Mattie, made the decision to leave. They had a total of ten children; five boys and five girls that my grandmother decided would be better off with the State, so she took all ten of her children to a state facility and left them there.

Once my grandparents were located, the State gave the boys to Grandpa Joe and the girls to Grandma Mattie, after she made it clear that she was unable to provide for all ten children on her own. My grandmother and the girls immediately relocated to Longview, Texas My abusive grandfather stayed St. Louis, with the boys.

I suppose my father had to have abandonment issues, which seriously affected my life. But it was the *other* issues that would literally turn me into someone else.

At that particular time in my life, Momma, my sisters, and I lived in a shelter. See, after coming back to Pat's the night "Auntie Pat" tricked me out for drugs, Momma, came back all beat up. She was yelling something about being set up to get gang-raped.

"Bitch, you set me up?" My mother screamed at Pat.

"What?"

"You heard what the fuck I said."

"I don't know whatchu talking about, Trina."

"Them niggas was waitin' on me like they knew what was up."

"What niggas?" Pat seemed oblivious.

"Yeah whatever, I'm finna get the hell outta here before I fuck you up!"

That type of drama was so commonplace by that point, I would just tune them out and await my next instructions; which was to get my sisters so we could leave.

My mother walked the streets in the middle of the night with three young girls until we reached an emergency shelter; which turned out to be more like a government-funded whorehouse. When the male staff couldn't get what they wanted from the residents, which appeared to be mostly junkies and prostitutes, then they would come for their daughters. Violation seemed to be becoming the story of my life, and even there I wasn't protected.

So the day that my father said he was coming to take me to Texas to his sister's funeral, I knew it had to be the best of a bad situation. My momma wanted to get rid of me even more than I wanted to go. But my mind wouldn't rest until I overheard my mother on the phone with my aunt discussing arrangements for my sisters. I would've stayed, if going meant leaving them alone with her.

The day he picked me up is one I'll never forget. He had his twelve-year-old sister, Lynn, with him. Lynn was his half-sister from his dad's new wife, Mildred; Mama Mildred, is what I called her. He had a bag full of new clothes that Mama Mildred had bought for me; I was so excited. I immediately ran to the facilities and changed into one of the new outfits. When I returned, Momma was all over my daddy, begging for affection. It was sickening to watch.

"You didn't ask if I want to go." She said.

"Trina, don't start, this a family trip." He told her.

"Whatever." She said turning her attention to me. "And you better get down there and act like you got some sense." She threatened.

I couldn't wait to be out of her presence.

The trip to Texas was long and hot. And I don't know where my dad found that beat up car, but I hoped we'd make it to Texas before it broke down completely. Luckily we did, but for me and Lynn, our luck ran out when we pulled up to my paternal family's house.

My dad pulled out the camera and started snapping pictures. I should have known then that he was documenting evidence of his presence; which really meant he didn't plan to be there at all. He walked out the door after about twenty minutes, leaving me and Lynn alone with strangers. The situation was so reminiscent of home it made me sick to my stomach.

From the moment Lynn and I walked through the front door I could feel something wasn't right. I wasn't greeted the way a child should be greeted when meeting their grandmother for the first time. And as for Lynn, she was the product of my grandmother's abusive ex- husband's new relationship, so they cared about her even less.

After my dad left, we stayed outside on the porch in the hottest weather I'd ever experienced. No one showed the hospitality you would expect from the South; we were left to fend for ourselves. When we were finally thirsty and hungry enough, we went inside to see if anyone would assist us. The children that I assumed lived there were in and out like the adults. I'd never seen children run so free.

I wasn't sure who lived there and who was visiting; everyone seemed so comfortable in a house with so many people and so much filth. My Grandma Mattie was most comfortable of everyone. She didn't seem to have a problem with all the commotion and disorder. In fact, when we came inside, she was on the couch sleeping through all of the madness.

Part of me was relieved that I didn't have to ask her for anything. She wasn't a very nice woman and she didn't seem to care for my father very much; it showed in her treatment of me. It didn't help that she was biracial and her skin was pale white; to me she was the mean, old, white woman.

Lynn and I decided to go to the room where we heard the most noise and the voices of some adults. When we approached the door I could smell the faint scent of marijuana and other familiar smelling chemicals. I'd often been exposed to marijuana by Floyd and my mother. They'd blow smoke in my face to watch my reaction for their own entertainment.

I slowly opened the door and exposed the indulgence of the room.

"Girl, close the mutha fuckin' door!" One of the men I assumed was an older cousin screamed.'

I immediately closed the door and looked at Lynn.

"Maybe we should knock." Lynn suggested.

Knock. Knock. Knock.

After a few seconds, a young woman snatched the door open.

"Man, what the hell y'all want?" She was even meaner than the man.

"I . . . we're hungry." I said nervously.

"I don't know whatchu tellin' me for, I ain't yo' babysitter!" She spat in my face as she yelled.

"Well, Grandma Mattie sleep and my daddy not here." I tell her.

"Well, that ain't my problem! Lil girl, you betta get outta my face and stay outta this room!" She continued to snap.

"But we hungry. What are we supposed to eat?" I pled with her.

The angry look on her face turned sinister and we had what felt like a stand-off. But before I had a chance to do or say anything, she marched towards me, and then snatched me up by the arm. I winced at the feeling of her nails digging into my skin.

"Come here!" She said as she dragged me out of the room.

Everyone watched in silence as she pulled me into the hallway.

"Let her go!" Lynn screamed, attempting to come to my rescue.

"Aw, you want some too?" My mean older relative threatened.

After a few minutes of commotion that no one seemed to notice, Lynn and I were locked in a closet, with no light. I don't know how long we were left there, but for the first time that day I was glad we hadn't eaten or drank anything.

By the time someone remembered that we were still in the closet and let us out, I was sick as a dog. I didn't know what was wrong at the time, but I was severely dehydrated. I finally got something to eat, but by that time I was so sick, I vomited everywhere.

"Curtis, you need to come get this chile, she sick!" My Grandma Mattie yelled through the phone at my dad. "I don't care if she my grand chile or not, you brought her here so this is yo' responsibility. And we not even gone talk about that otha gal."

When she ended the call, I was confident that this nightmare was over. But the longer I waited and the sicker I felt, the less confident I became.

As I dozed off with my head in Lynn's lap, I had a dream about being back home. Everything was completely normal and I was even happy. But that happiness was abruptly interrupted by the sound of my father's drunken voice.

"Wake up, Daughter of mine. Here, drink this." He said handing me a 7up soda.

"Daddy, I wanna go home." I begged.

"Me too." Lynn backed me up.

"We gone leave after the funeral tomorrow." He told us.

Lynn and I looked at one another with disappointment, and a single tear ran down my face.

"Alright, I'll be back." He told us before staggering out the front door.

We saw Curtis Frazier the next day at the funeral, then again a week later, the day he picked us up to go back to St. Louis. During that week, Lynn and I had to fend for ourselves just like the other children. We stayed as far away from the adults as possible, if we didn't want to get hit or thrown in the closet for hours.

The day we arrived there, I had two bags filled with clothes and undergarments. But the day we left, all I had were the clothes on my back; which was the same outfit I had on when we arrived. So needless to say, I was beyond filthy and so was Lynn. My introduction to my paternal family was as dysfunctional as the rest of my life, so much so that all I wanted was to go home.

We finally hit the road back to St. Louis. We didn't get far before the heap of junk my dad was driving broke down. I was screaming on the inside and all I could think about was getting back to Leah and Torie.

My dad's cousin finally made it to pick us up from the side of the highway. Before Mildred paid for two one-way airline tickets back to St. Louis for me and Lynn, leaving my dad to get back home on his own, I had to listen to my dad argue with my mom for what seemed like forever. They argued like I was actually a top priority.

After catching a cab to the airport and flying home with no adult supervision, Lynn and I were both elated to see our mothers awaiting our arrival. My momma greeted me with a hug that almost felt genuine.

"Where's your stuff?" Momma asked, looking for the bags I left home with.

"They took everything, this all I got." I told her, looking down at the clothes I was wearing.

Momma started to spew obscenities about my dad. I just tuned her out as usual and I got in the backseat of Mama Mildred's car. She didn't say it, but I could tell from her silence that Lynn was as traumatized as I was. And although we were distant in age and location, we bonded that week that we were forced to protect and defend on another.

Lynn experienced what it was like to be a victim of child abuse on our trip out of town. And sadly, I already had too much to compare it to.

Chapter Five
The Disconnected Piece
(Leah)

Even as a child, my first priority was my little sisters. Leah had been my responsibility from the time I was three-years-old and I loved her so much that there was nothing I wouldn't do for her; even sacrifice my innocence. But by the time Torie was born, and Leah was about four, something in her changed.

After coming back from Texas with my dad, it wasn't long before Momma got tired of the shelters and found another place with Floyd. I never understood her reason for leaving in the first place if she was only going back to the same thing. Consequently, things for me only got worse.

I was already behind in school because I refused to go when Floyd was home alone with my sisters. But the damage he did to Leah was done right in plain view and there was no need to hide behind closed doors. There was nothing productive about his presence, especially with Leah.

He had eventually programmed her to assist in his abuse. Because of his treatment, Leah caught on to the fact that I was of lesser importance than everyone else. She started to do things like cry out for no reason, and when Floyd would come to her rescue, she'd act like I hurt her. I pray she was unaware of what the consequences of her actions meant for me.

Nevertheless, I continued to love her despite her being brainwashed. Something in me knew that even this form of abuse was all Floyd's doing. It went along too well with everything else he did, like keeping me and Leah in competition with material things.

His sociopathic behavior only hindered what would have otherwise been a normal sibling relationship. I didn't understand it then, but at some point in my life, I realized that it was his sick way of tormenting me whether he was in my life or not. Floyd was breeding my sister to continue his abuse in the event of his absence.

I was eight-years-old and my life was everything I wish it wasn't, with the exception of the community church I attended with the children in my new neighborhood. Going there gave me a temporary relief from the hell I was becoming accustomed to. I seemed to be an outcast everywhere but there. The people accepted me with open arms and no one wanted anything from me. It was one of the only times in my life that I was happy; even if it was only temporary.

I realized early on that a person's happiness can be altered in the blink of an eye, by anyone. The sad thing was, my happiness always seemed to be in the hands of another person.

I'll never forget the day of the contest at church. The children's church devised a contest for the child that brought the most visitors, to win a new bike. I remember inviting anyone in my neighborhood that would listen. To my amazement, far more people showed up than I expected. I learned that there's something about the conviction of God in a child's innocence that moves people.

As determined as I was to win, I did not for one minute think that I actually would. When I walked into the sanctuary, I was surprised to see the faces of the people I'd invited. When I took my seat I was so anxious at the thought of them announcing my name, that I couldn't stop my hands from moving.

"Why are you so fidgety?" One of the girls in my class asked.

"Nervous I guess." I told her.

"Why? Ain't you ever had a bike before?" She asked.

I just looked at her without answering, and then turned my attention back to the front of the church. Some of the children already thought I was a little strange, so I avoided any opportunity to prove them right. Her eyes burned a hole in the side of my face until she gave up awaiting a response.

I sat up straight in my seat to hear the Pastor's announcement.

"I would just like to thank all of the visitors for worshipping with us today; you are definitely welcomed. I'd also like to applaud the Children's Ministry for their contribution to the cause of winning souls for the Lord."

The people applauded and gave praises to God.

"So without further ado, I will announce the winner of a brand new Huffy bicycle!"

I was on the edge of my seat and the only thing I could hear was the sound of the Pastor's voice, coupled with my heartbeat. My eyes followed the purple and white metal masterpiece, with a white banana seat, and silver and purple streamers, as they wheeled it to the front.

"The youth member with the most guests, therefore winning a new bike is . . ."The anticipation was eating me alive. "Anna Frazier!"

Happy, couldn't describe how I felt. It was like a jolt of lightening hit my body, and I ran to the front as fast as I could. The sounds of the cheers and applause were muffled and things seemed to move in slow motion. My eyes were fixed, and no one or nothing else mattered at that moment. It was just me and my shiny new bike.

When the service was over, I rode home as fast as I could to show off my new toy. I pulled up to the unit and carefully rested my bike on its kickstand.

"Momma! Momma!" I yelled, as I ran through the apartment.

I went from room to room looking for my momma, but to my disappointment, all I found was Floyd.

"What the hell you makin' all that noise for?" He grunted.

"I wanna show my momma my bike." I told him.

"Aw yeah? Let me see it." He said.

The fact that he seemed even slightly interested in my happiness made me let my guard down just a little bit. Floyd followed me outside where my bike was parked.

"Where this come from?" He asked.

"I won it at church." I explained with pride.

The look he gave me was vindictive. His eyes seemed to darken with his sinister scowl. I didn't understand, but my attention was quickly diverted when Leah ran up. More than wanting a bike for myself, I couldn't wait to teach my little sister how to ride it.

"Ooooh, who bike is this?" Leah asked.

"Mine. I got it from church. C'mon, let me show you how to ride it." I told her.

We left Floyd standing in the doorway and ran straight to the sidewalk with the bike. I looked up to see his silhouette disappear into the apartment. He despised the moments when Leah and I were at peace together.

"Get on." I instructed Leah, as I put one hand on the handle bars and the other on the seat. "Okay, now peddle and then I'm a let you go."

I ran beside the bike for about six or seven steps before I took my hands away. But Leah only made it two or three feet before she fell.

"Aaaaah!" She cried out.

Leah was on her butt and the bike was on her leg. Before I could even consider what to do next, Floyd came running to her rescue. I lifted the bike from her leg and tried to help her up.

"Leave me alone! You pushed me!" She lied as she looked directly into Floyd's eyes, as if they shared some sadistic bond.

"No I didn't!"

My sentence was barely complete when Floyd grabbed me by the arm, threw me on the ground, and handed my bike to Leah.

"Here, this yours. She don't deserve no bike." He told Leah with his eyes fixed on me.

Once more I'm crying on the inside and I refuse to give him the satisfaction of my tears.

"You betta not touch this bike, or else." He threatened before he walked back into the unit.

I didn't say anything to Leah. I just watched as she dragged the bike that was taller than she was, into the apartment. She never rode the bike, because no one would take time away from their dysfunction to teach her.

She asked me again about a week before the bike was sold for drugs to teach her to ride. And despite what Floyd said, I was determined to help her. We practiced for what seemed like forever, and I was finally able to take my hand off the handle bars.

"You almost got it Lea, just keep the front straight." I told her as I ran behind her still holding the seat.

A cold chill ran down my spine when I saw Floyd watching from the doorway.

"Come here, Anna!" He yelled.

I looked at Leah, then back up at Floyd. Her face was innocent. Just as it was the day she told him that I pushed her off the bike. I felt set up. And I still believe that feeling was all a part of his plan.

Moving slowly toward the door, I kept my eyes on the ground until I reached the small porch and walked into the living room.

"Yes sir?"

"Didn't I tell you not to touch that bike?"

"But I . . ." I tried to explain.

"But my ass! Get up here!" He called me to the top of the stairs on the second floor.

I felt so hot, I thought my insides would melt. This was the last thing I wanted.

"I just wanna go back outside." The knot in my throat was apparent in my tone.

"Get yo' mutha fuckin' ass up here now!"

I walked up the steps in slow motion as I counted them in my head . . . ten, eleven. I stood at the top of the stairs waiting to see what was coming next.

Floyd bent down to look me in the eyes.

"The next time I tell you not to do something, you betta listen. Turn around." He said.

There was a few seconds of silence. Then I felt a sudden jolt of force from behind, that sent me flying down the stairs. By the Grace of God, I was okay physically. But the internal bruising was only made worse when he stepped on me as he came down the steps. I still refused to relinquish my tears.

I learned early in life that love and trust don't go hand in hand. Sometimes loyalty is based on who can give you the most "stuff". But honestly, all I wanted was the love. Unfortunately, I wasn't quite sure where to look. I had been told that God was always there, but he didn't seem to see what was happening to me. My mother was so caught up in her own dysfunction, I'm not sure if she could show genuine love even if she wanted to. But with Leah, I thought there was a bond that no one would ever be able to penetrate. But somehow, Floyd found out how to steal yet another piece of my life; my little sister Leah.

Chapter Six
The Shattered Piece
(PaPa)

By the time I turned nine-years-old, I started to display signs of serious psychological issues. Which turned out to be one of the things I inherited from my father's side of my bloodline. I remembered getting in trouble for things I couldn't remember doing, which to me felt like even more abuse. I realized myself that I was becoming slightly detached when my "protectors" started to reveal themselves to me. They seemed to know things about different people and places, and they were always right.

They were heard and never seen, but they would warn me every time I was in danger. I could hear them as clearly as someone standing right beside me. I even recall them helping to usher me away to a safe place during my many violations. But the safety was only for my mind; which was already severely damaged. And as for my body and soul, I felt there was nothing in my power that could be done.

I knew that hearing voices was not something that "normal" people encountered, so I tried my hardest to not allow them to alter my personality. Needless to say, that was a difficult task considering they were my only friends. How could I ignore them? I couldn't; they protected me from everything that threatened to hurt me. At least that's the way they made me feel.

As detached as my mind was becoming, I was still very in touch with reality. So when I met, "PaPa", for the first time on my ninth birthday, I knew he was real.

I didn't get excited like other children on their birthdays, because my situation was hardly typical. I didn't expect a party or gifts like I should have, because I already knew that any money or anything of value was designated for their habit. The fact that it was my birthday had no bearing on their decision to not be addicts for the day.

Deciding to put my newly nine-year-old imagination to use, I got all the kids in the neighborhood together to celebrate with me. I hadn't imagined that I would enjoy myself as much as I did. I almost forgot how miserable my life actually was.

We played music outside and danced in celebration of me. Just to have fun and enjoy the company of others without being blamed, ridiculed, or abused, was birthday present enough. There seemed to be more children outside that day than I'd ever seen at one time, and I was glad.

"Anna, when yo' momma gone cut the cake and let us sing Happy Birthday?" One of the neighborhood girls asked.

"Aw, she said later." I lied, looking at my mother's guilt ridden face as she stood in the screen door.

It wasn't long before several more of the children began to inquire about food and cake. I managed to stall them all long enough for the make-shift festivities to die down and the children to start heading home. The sun had gone down, but I was still reluctant to go inside. I didn't want the reality of my true existence to ruin the day that had been mine, all day long. So, I lingered outside as long as I could.

Although it was warm for February, the night air was too cold for me to bear any longer, so I finally went inside to face the reality that the celebration was over. Leah and Torie had been in the house for hours, watching TV with Floyd. I could hear Momma in the kitchen cussing under her breath as she struggled with a carton of eggs.

"What's wrong, Momma?" I asked her.

"Hey baby." She seemed surprised to see me standing in the kitchen doorway. "Momma just tryna make you a cake for your birthday, that's all."

But there was something wrong. She needed a fix. Her mouth wouldn't stop twitching and her feet wouldn't stay still. It was like she was walking in place. The tale, tale sign was the fight she seemed to have with the egg carton.

"Can I help?" I asked reaching for the eggs.

She looked around and scratched her head, but the imaginary object just wouldn't appear.

"Naw, you know what? I'm a do it later, I promise." She lied.

I could see the guilt in my mother's eyes earlier that day. She had every intention of attempting to make my birthday special, but the demons inside her wouldn't allow her soul to rest.

'Floyd! Come here man!" She yelled over my head.

That was my cue to exit stage left. But I could still hear their conversation from the living room.

"Let me hit somethin' Floyd; I know you holdin'." She begged.

"Bitch, you betta get out there and get it how you live! I ain't givin' you my shit, I'm straight." He laughed at her desperation as he spoke.

"You know that's real fucked up." She snapped. "I'll be back!"

She grabbed her coat and walked straight out the front door. Floyd, however, came straight into the living room and took a seat in his chair.

"Y'all take y'all asses in the room and play or something." He ordered.

I grabbed Torie's hand and Leah slowly made her way to her feet.

"But Daddy, I wanna finish watchin' . . ."

"Go play Leah. I ain't gone say it again." He told her.

Leah put her head down and dragged her feet all the way up the stairs. She quickly got over Floyd's rejection when I suggested that we play school. I was the teacher, and Leah and Torie were two of my students. There were seven other students portrayed by stuffed animals and dolls. We also had an imaginary Principal whose office was the closet. We played peacefully for about thirty-minutes before Floyd came to the door and gave me that familiar look. He said more with his portentous eyes than he ever could with his mouth.

"Come on." He said as my cue to come to his and my mother's bedroom.

My heart dropped to the pit of my stomach and I could feel vomit at the back of my throat. I was tired of it, but I didn't know what to do. I would have killed myself, but I couldn't bear the thought of what he would do to them; my babies. The knot in my throat only allowed me to say four words before walking out and locking the door.

"Y'all, stay in here!" I demanded.

As I slowly approached the door where he was waiting, I had my mind made up. This was it. I wasn't going to take it anymore. I opened the door.

"No!" I screamed.

He chuckled like I had told a joke.

"No? No what?" He asked.

"I'm not doin' it. You can't do this to me anymore!"

"Okay then, you don't have to. Let me see what your sisters think about that." His voice was calm; too calm.

The knot in my throat produced silent crocodile tears that I couldn't hold in. Multiple tears fell from my chin, nose, and lips, saturating the front of my shirt. He gave me direct eye contact as he started toward the door.

"No! Okay, please don't hurt them." I cried.

"Put this on."

He threw a frilly white night gown at my feet. Nothing sexy at all, just a pretty white gown with lacey edges along the top, fit for an underdeveloped nine-year-old girl.

"I'll be back." He said walking out of the room

I stood there alone wishing my 'protectors' would help me. They would usually have warned me by now, but they were silent; unusually silent. I decided that compliance would be best for me at that moment, so I changed into Floyd's requested ensemble.

I sat on the bed replaying the incidents from the past in my head. I thought that reminding myself of what to expect would make it easier to endure. But it never did, it was equally or even more morbid and perverted every time.

But this time was different. There was something different in Floyd's eyes that day that was confirmed when he returned to the room with two other men. They all appeared to be high out of their minds. One of them I recognized as Floyd and my mother's dealer; the other was one of Floyd's crackhead friends.

"Yeah man, she ready. She cook, clean and everything." Floyd told the others.

"She gone grow all the way up today." The dealer said brandishing a shiny silver gun with a long barrel, as he unbuckled his belt.

The crackhead didn't say anything, he just followed suit with the others.

"Birthday Girl, ready for your present?" Floyd asked.

"No! I don't want anything from you!" I snapped.

"It's time for you to be a grown woman now." It was the last thing he said to me before my life changed.

The room began to grow dark and cold around me, but I was the only one in the room that seemed to notice. I could feel the violation happening to my body, but their faces were a temporary distraction. All three of their faces began to change into something demonic. Their mouths were disfigured and their eyes turned black. There was barely a glimpse of humanity left in them. I could not only see, but I could feel their darkness; it was frightening.

It wasn't until they held me down and took turns raping me that I saw him; PaPa. He was as tall as the ceiling and resembled a shadow with horns. Only he was no shadow. His red eyes froze my heart as he opened his mouth and showed his jagged jackal-like teeth. The only noise he made was the heavy breath he used to snort like a bull when he took his clawed hand to fondle himself. I watched in horror as my eyes traveled down his giant essence. I noticed that from the waist down, his muscular torso was attached to the body of an animal with hooves and a massive penis.

He seemed to be commanding the trio of demons to violate me in anyway possible; up to and including using the barrel of the shiny gun to penetrate me in between the rapes. PaPa, (the name I came to call him) seemed to enjoy my horror and delighted in the fact that I could see him. He fed off my fear, I know that now.

My nine-year-old body endured everything from oral to vaginal to anal penetration. I eventually went somewhere else in my head when the pain became more than I could bear.

As the little miracle girl died that day, I wished all of them would have died with her.

The next day

Momma was home, but she was sick and couldn't get out of bed. So I waited until I had a minute to be alone with her and I went into her room.

"Momma, can I talk to you?"

"Girl, what now? I don't feel good, shit."

"Momma." I didn't know what to say. "Floyd and his friends, hurt me last night."

"What are you talking about, Anna?" She was dismissive once again.

"They raped me." I told her with tears streaming down my face.

But what my mother did next, hurt me far more than PaPa and his minions.

Slap!

The sting of her hand was a betrayal I would never forget.

"You still tryna mess stuff up? I told yo' ass before, don't nobody want you, heifer! Hmm, you probably hit on him, talkin' about somebody raped you." She chuckled under her breath. "Did you like it?"

I broke down. I couldn't believe what she said to me, her nine-year-old daughter.

"But Momma, they hurt me!" I cried.

And for the second time in my young life I was exposing my privates to my mother to prove my sexual, emotional, and physical abuse to her.

"Get yo' fast ass outta my room! I don't have time for this bullshit!"

I looked her in the eyes and dried my tears. When I left my mother's room that day she was no longer, Momma, she was Mother. And I didn't cry for at least ten years after that. Happy Birthday to me.

Chapter Seven
The Secret Piece
(Shelby)

My ninth birthday was just my graduation into another realm of molestation. By the time I was twelve, having sexual intercourse with Floyd had become a normal occurrence, and so was PaPa's presence. Floyd would occasionally invite one or two of his friends to join, but mostly it was just him. He was attempting to turn me in to her; Mother.

The word must have gotten around, because before long, boys seemed to come from all over the neighborhood to get a touch, freak, or a peek. Sadly, my esteem had been reduced to make me believe that it was my purpose. Sexually satisfying men is what I was supposed to do, right? By the time I realized that wasn't true, the damage was irreversible it seemed.

I wasn't pretty; at least not to me. My clothes were old and dirty. My hair was never combed. So, it was obvious what they wanted, and Floyd had trained me to oblige them. I can't say if he received payment for my services or not, but it seemed strange that I suddenly became the center of everyone's attention.

I'd watch the other children's faces and I would try to mimic what a happy child is supposed to look like. But the absence of light in my eyes and subsequent sadness was something I was unable to keep disclosed. Being accustomed to less than suitable living conditions made the roach and rat infested apartment seem normal.

We were used to protecting ourselves from the inside elements. Checking the inside of shoes, drawers, and closets to ensure our safety, had become a way of life. Material things were of no importance to me, I was just grateful for whatever we got. But Leah, on the other hand, had become obsessed with material possessions. It seemed that was all Floyd's side of the family had to offer her; stuff . . . things, things that would eventually ruin Leah's perspective on life. But in the meantime, our lives perspective was already in the process of destruction.

The summer after I turned twelve, we moved back to the hood. There was so much happening in my life, I could hardly keep track. I just made sure that my little sisters remained untouched and unharmed. By that point in my life, Leah and Torie were my only reasons for living, but I started to wonder if even they were reason enough.

But, being in the neighborhood where I grew up made it somewhat manageable. At least we were around people that were familiar with our situation. So, if we were hungry, we had places to get food. There were also people that knew and accepted me like, Jermaine.

He was a boy about my age that was close to my family. He was at times, a temporary haven away from all I had to endure on a daily basis. I had no idea how instrumental his friendship would be to my future.

However, the physical and sexual abuse continued along with overall neglect. So when Mother ignored it when I told her how much pain I was in, and about the constant bleeding and vomiting, I wasn't surprised. I just took the pain like I had for the last eight years.

Then about two months later, Mother came home clear-eyed and focused, and as sad as it sounds, I knew something was wrong. It should have been a relief that she wasn't high, or trying to get high. But it always seemed when things were at their most normal, it always meant something disastrous for me.

My fears were confirmed the moment the police pulled up to our building. Mother picked up Torie and seemed to brace herself as if she knew what was happening. The officers approached the open door and knocked on the storm window.

"I'm looking for Trina Simms." The Black officer said looking through the screen door.

"That's me." Mother said as she opened the door to let them in.

I couldn't understand for the life of me why she would voluntarily allow them into this critter infested shack.

"We're supposed to meet Mrs. Ashley here to escort the children to the Division of Family Services Facility."

I thought the words he said would stop my heart. But when they didn't, I grabbed Leah's hand and we ran. And as soon as we got out the back door, Leah broke free and took off.

"Leah! Come back!" I screamed.

But she took off through the backyard without looking back. I ran to the neighbor's house and knocked on the back door.

"Who is it?" Tanya yelled.

Tanya was the neighbor, Ms. Margaret's niece. Chances were, Ms. Margaret was already on her front trying to find out what was going on.

"Anna." I whispered.

Tanya snatched open the door, clearly clueless as to what was happening.

"Girl why you whisp . . !"

"Shhhh! Be quiet. Let me in."

I pushed my way into the kitchen and ran down the basement steps. Tanya and I were about the same age, so I didn't worry that she would tell.

"What's going on Anna?" She asked.

"I think my momma finna let them take us." I told her.

Her silence spoke volumes as she plopped on the couch with a look of pity on her face. We didn't say much, I sat for about thirty-minutes in an effort to wait out the police. Finally, I stood and took a deep breath and Tanya stood with me.

"I'm finna go." I told her.

She followed me up the basement steps and peeked out the back door.

"I don't see nobody." She said.

I stepped outside and looked around trying to see if I could hear any familiar voices. Before dashing between the buildings, I turned back to look at Tanya.

"Thank you."

"It's cool." She told me closing the door.

But I didn't get five steps before I heard, "Here she is!"

I shuffled from left to right, but my legs were confused about which way to go. By the time my legs caught up with my brain, I could feel the officer's hand around my arm.

"Come with me, Young Lady." The unusually muscular policeman said.

He led me to one police car that held my baby sister, Torie. And the second car is where Mother sat, trying to avoid eye contact with me.

"We have the whereabouts of your sister and we're going to pick her up. After that, we will meet Mrs. Ashley at the Station and she'll take you from there." The officer explained with empathy.

He spoke like he owed me an explanation for my mother. I was angry with him, but it wasn't his fault; he was just the messenger. The problem was, no one had officially explained anything to us. Mother had every opportunity to sit us down as a mother should, and give us some guidance, instruction, or at least a reason, but she didn't. She treated this like she treated everything else, like it didn't exist.

We went one way and Mother another as we were all hauled away in Police custody. I looked out the window at the houses we rode past. Then I leaned my head against the glass and watched the reflection of the houses as I looked up at the sky. I wondered what kind of lives the children in each house lead and if their lives were anything like mine.

The sound of Leah crying and resisting as the officer took her from her paternal grandmother, snapped me out of my haze. I picked Torie up, held her in my arms and swallowed the tears that formed a knot in my throat. I had to stay strong for my babies, Leah and Torie. Mother left me with the responsibility of finding someone that would take all three of us in. I couldn't be separated from my only reason for living.

I felt that way, and I couldn't understand how the woman that brought us into this world could not show and ounce of empathy for the situation. It was like she ran away from us without a thought as to where we would wind up. I know that there were things that she was going through as well, but she never seemed to make us a priority. And even when she did, it was still all about her.

After hours of making calls and waiting on someone to return those calls, my older cousin, Dana, and her husband, Derek, came to the DFS Facility to pick us up. All three of us were filthy. Our clothes were dirty and our hair was a matted mess. My cousin cleaned us up and bought us new clothes. I could tell she felt sorry for us, which was probably the main reason she took us in. But I'm grateful, otherwise, who knows where we would have wound up.

I could see that after a few months, things started to become difficult for my new guardians. It wasn't easy dealing with three girls on top of having two boys of their own. I could only imagine the stress she endured while trying to make us feel wanted.

They took care of us the best they could, with the resources they were given. But I don't think anything could have prepared Dana for everything Mother neglected.

"Dana, I don't feel good." I said standing in the doorway of the kitchen as she cooked dinner.

"What's wrong baby?"

She turned to face me and no reply was needed. It was obvious that I was in need of medical attention. I had lost a considerable amount of weight from my already petite body. I was pale and the dark rings under my sunken eyes, told my battered body's story. I suppose she had been too busy taking care of everyone to notice before.

Dana walked over and touched my head, and then looked down at my belly. We made eye contact, but she didn't say a word. I remember her waking me up the next morning, telling me to take a bath and get dressed. I had to admit that I was relieved to have someone interested in my life and well-being, but I wasn't prepared for the questions. After riding quietly for about fifteen-minutes, she broke the silence.

"What happened to you, Anna?"

My eyes burned a whole in my lap as I fiddled with the seatbelt. The last thing I wanted to do was answer her question. Then I gave her a side look with eyes full of tears that I refused to let fall.

"Does your mother know?" She continued to question.

My stomach turned at the sound of the word, Mother. I snatched my head around and burned a whole in her eyes with mine, confirming everything she thought with the silence and hatred they held.

We rode around in what seemed like circles for about an hour. Dana finally pulled up to a brown brick building with no sign or markings to indicate where we were.

"Where are we?" I asked, speaking my first words of the ride.

"Don't worry, they'll take care of you." She told me.

Don't worry? How do I do that? My whole life had been nothing but worry up until that point. But, I tried to trust the first person to come to my rescue. I followed her inside and sat in the waiting area with several other seemingly emotionless teenagers.

"Anna Frazier!" My seat wasn't even warm before a nurse called my name. "Right this way."

Dana and I followed the woman down a long hallway. My anxiety was reminiscent of the way I felt when approaching the door of Floyd's bedroom upon his request. I was afraid, and my legs threatened to give out with every shaky step. When we got to the room, everything was pretty standard. She took my vitals and gave me a gown to change into, and then told me to take a seat on the examination table.

The nurse left the room, leaving Dana and I alone again.

"You alright?" She asked.

I nodded. But when the door opened, all of that changed. A tall, large, white, male doctor walked in with the nurse. My first reaction to stop breathing, proved to be a bad idea when I became light-headed. The deep breath I attempted to take turned into a blood curdling scream the moment I saw the doctor's massive hand reach out to touch me. Needless to say, he was immediately replaced with a female doctor.

Any suspicions Dana had were confirmed with my reaction to the doctor. Her face was filled with pity as she reached over and stroked my cheek. I flinched when I felt her soft hand. What she didn't realize is that I didn't like to be touched, by anyone. I had been ruined, literally.

After a pregnancy test, ultrasound, and pelvic exam, it had been confirmed that I was carrying someone's child. It could have been Floyd's, or a number of other males from my neighborhood.

The disgust on Dana's face was apparent as she listened to the doctor describe the damage that had been done to my premature reproductive system; not to mention the plethora of sexually transmitted diseases I had been diagnosed with. I was just lucky not to have been given a death sentence at age twelve.

"It's truly a miracle that she hasn't hemorrhaged internally. Her body is not equipped for all it has appeared to have gone through." The doctor spoke as if I wasn't there.

"Well, she'll be taken care of now." Dana said rubbing her hand down my back, which made me uncomfortable once again.

"That's good to hear." She smiled. "So, are we taking care of this today?"

"Yes, I think that'll be best." Dana said.

"Okay, we'll go get set up. Be right back."

The doctor left and again Dana and I were left in silence.

"Anna?"

I looked at her without a word.

"You'll feel better if you talk about it." She said.

I took a deep breath, and began to spill the secret of my seed. The look on Dana's face while I spoke, ranged from sorrow to sheer anger. She shook her head as a tear escaped her eye and fell into her lap.

"It's a vicious cycle." I think she spoke without realizing it.

"What?" I inquired.

She looked up at me like she almost forgot I was there.

"Whatchu mean, cycle?" I asked her.

Now it was her turn to take a deep breath and bare her soul. But I almost wish she hadn't. She revealed almost four generations of incest and molestation in my family that made me sicker to my stomach than I already was.

She told me a story that started with the anointing of my great-grandfather to found a church that became one of the most prominent in the city. But it had apparently also become one of the most corrupt, although, not by my great-grandfather's hand. It was the demons that slithered and tricked their way into his church just for that purpose.

So, if the story of my uncle being molested by a male officer of the church while he was a little boy wasn't enough, she surely had enough dysfunctional stories to go around.

The ones I found most interesting, however, were the ones about my mother and grandmother.

"Your mother was molested too."

And the plot thickened. But how she continued to call rape, molestation was beyond me. Although appropriate for the situation, molestation seem too elementary of a term for the things I had experienced.

"Your Grandma Lily lied to her husband at the time, and told him that your mom and Aunt Rita belonged to him. And when he found out they weren't, he started to do things to them. My momma said it was all supposed to be so hush hush, but everybody knew and just turned a blind eye. I couldn't comprehend how a mother would allow this to continue to happen, and then I found out that the same thing happened to your Grandma Lily, by her step-father."

I couldn't believe what I was hearing, and I wasn't sure how I felt about it. Should I feel sorry for Mother, or should I be angry with her for ignoring my misery?

"In fact," Dana continued. "I think this is supposed to be a secret as well, but your Aunt Rita's ex-husband raped Anita, and her daughter Tracey is actually his daughter."

"My mother's little sister, Anita?" I was in awe.

"Yep. So like I said, vicious cycle." She shook her head again and looked at the floor. "Anna?"

We looked up and met eyes at the same time. "Huh?"

"The girls, Leah and Torie . . . have they?"

"I'll kill him if he ever touches them."

I didn't raise my voice, but I believe that the look in my eyes alone let her know that I meant every word, and I did.

When the doctor entered with the nurse, our conversation ended.

"Well ladies, let's get started." She said. "Right this way."

She escorted us to what looked like a miniature operating room, where I was instructed to take off my clothes again and change into another gown.

"Here, put your clothes in this." The nurse handed me a white plastic bag with no writing on it.

In fact, nothing seemed to be labeled; the bag, the building, the paperwork, nothing. So I came to the conclusion that the facility had to be top secret.

As I was left alone to change, I examined the room and the utensils that were strategically placed at the foot of the large examination table. I didn't know what to expect and that made me scared. But, there was something about fear that made me angry.

I heard a light tap on the door before the doctor and nurse reentered the room.

"You ready?" She said as she peeked around the door.

I nodded. Then I tried to look behind them to find Dana.

"Oh, she's in the waiting area. I'll send her right in when we're done, okay?" The doctor told me in an effort to keep me calm.

I nodded again, but I didn't really understand. I didn't know what was about to happen to me. I lay back like I was told and placed my feet in the stirrups.

"This should help you relax."

That was the last thing I could clearly remember, everything else was a blur; the pushing, the pain, the moment the nurse left the room with my baby. I don't know how far along I was or if the baby even survived, but I knew that I would never forget the name I would've given him or her had I been given a chance; Shelby.

Chapter Eight
The Separated Piece
(Mama Mildred)

My life was at its most normal when I lived with Dana and Derek, besides my spurts of unexplained and unremembered bad behavior. I commended them for trying as hard as they did, with what they had to work with.

As far as men went, Derek, was what I would have considered a real daddy. He was the closest thing to a nurturing and trust worthy man that I had ever been exposed to. Dana, however, seemed to be dealing with some deep rooted issues that began to show in her treatment of us.

I suppose Leah's constant lying and stealing didn't help the situation. She seemed to resent the fact that she wasn't with Floyd's family. She didn't have the *things* she wanted and felt she would have if she lived with them. Leah would steal from Dana and Derek, and then tell them it was me. That, coupled with my own behavior made things even more difficult for the young couple, with a young family. This went on for about a year until Dana realized it was too much for her.

Between my time loss and Leah's complete defiance, Dana and Derek had taken on too much. So, before long I was sent to live with Mama Mildred, my biological dad's step-mother. Leah went to Floyd's mother, Gwen. And my baby sister, Torie, was sent to foster care. It was sad because Torie was the least problematic, but she was the only one that had to live with strangers.

The thought of being separated from them gave me a feeling of hopelessness and I could no longer protect them. I had to leave it up to God. I prayed every night that Floyd would not hurt Leah the way he hurt me. And I prayed that where ever Torie was that she was safe.

I was away from my sisters, but I was in a safe place. Even though Mama Mildred was not my biological grandmother, she treated me like blood family. She was one of the sweetest people I had ever met and even seemed to sympathize with my situation. She was very delicate with me and was always careful about the people she allowed in my presence. I believe she could sense my distrust. I still couldn't understand how a woman so sweet, could end up with a man as mean and surly as my grandfather. Luckily for her, she outlived him and his abuse.

By that point, Aunt Lynn, my dad's youngest sister, was away at college and it was just me and Mama Mildred. I'm not sure if it was her understanding nature or the fact that she got a chance to really know me one on one, but my psychotic episodes didn't seem to move her; at least not on the surface. But, she was the first person that didn't ignore what was happening to my mind.

"How you feelin' today?" Mama Mildred asked.

"Cool." I said, as I colored in the whites of LL Cool J's eyes on the cover of a Jet magazine. "Why you ask me that?"

"Cause, you didn't have a very good day yesterday."

I looked up at the ceiling and tried to jog my memory, but I came up with nothing. In fact, I barely remembered getting out of bed the day before.

"I can't remember much about yesterday." I told her.

"Yeah, I figured as much. Come here, let me show you something."

I put the magazine on the coffee table and followed her into the kitchen. Upon my entrance, I was in utter disbelief at what I saw. The kitchen was in shambles. There were broken dishes and trash everywhere. As I walked further in, I noticed the words "DIE" AND "I HATE MY FATHER" written multiple times in ketchup all over the walls.

I couldn't speak. I just looked up at my Mama Mildred with my mouth open and tears in my eyes.

"I started to clean it up, but this was worse than the other times and I needed you to see." She said.

"Other times, I've done this before?" I asked on the verge of an emotional breakdown.

"Well, yes. I mean, no. I don't think it was you, at least you said it wasn't." She seemed as confused as I was. "Usually you'll stay in your room. I'll hear these rants and the sound of you throwing things. After you told me you weren't Anna, you were NuNu, I left well enough alone and let you get out your frustrations. But yesterday was different. You didn't even look like yourself."

By the time she finished describing the prior day's events, I was completely distraught. Tears and snot covered my entire face.

"I'm so sorry, Mama." I cried. "I didn't hurt you, did I?"

"Child no, I just left it this way so you could see what's going on for yourself."

I looked around the kitchen and tried to imagine the person I know myself to be, causing the destruction I beheld. Overcome with sorrow and regret, I fell to my knees and at Mama Mildred's feet.

"I promise I'll clean it all up! Please don't send me away!" I pled.

"Anna baby, get off that floor. Ain't nobody sendin' nobody nowhere. I'm just tryna help you, that's all. I figured you didn't really know what was happening. How's things at school? You seem different when you come home lately."

I paused, looked at my grandma, and proceeded to tell the biggest lie I had ever told her.

"School is good. I got a lot of friends too." I told the wide-eyed tale.

"Okay, well you got somethin' else you wanna talk about?" She asked.

Even after over a year, the first thought that came to my mind was Floyd. He had tainted every morsel of my soul, it seemed.

I immediately looked up at Mama Mildred.

"No, I don't want to talk about, him." The disgust in my tone was apparent.

"You don't have to talk about nothin' you don't want to." She said gently rubbing my shoulders. "Now come on, help me clean up this mess."

We spent the next two and a half hours cleaning and putting the kitchen back together. She never mentioned how disgusted she may have been with my behavior, and I never mentioned the loneliness I felt while enduring the bullying and abuse from the demon spawned children at my new school. I just pretended that everything was normal so I wouldn't make any more waves in my already turbulent existence. All I wanted was some normalcy in my life.

The next day at school

Being intelligent, for me was overrated. I suppose it was because no one really knew it, at least no one that mattered, like my Teachers, Counselors, and Principal. When I wasn't in trouble for defending myself against my seemingly invisible bullies, I was being called out for purposely trying to avoid attention in the classroom. I couldn't have been any more misunderstood, or miserable for that matter.

Every day it was the same thing; I got kicked, punched, hair pulled, and even jumped on occasion. It was the same sadistic group of children that would take turns with their unprovoked torture.

I never talked about anyone or got in the middle of drama. In fact, I pretty much kept to myself. But I slowly began to realize, that was the problem all along. No one liked "different", and as far as they were concerned that's what I was.

I refused to do what everyone else was doing, because I was always interested in other things. But, Theresa, the ring leader of the group, didn't seem to like that very much. Apparently, no one else was allowed to think unless she told them it was okay. But me, I wasn't a follower, and bullies don't like that. She would always sick a different group of kids on me; sometimes even boys. But about a week earlier, I came up with a plan.

See, what Theresa had was power in numbers. I was powerful, but I was all alone. I decided that for all intents and purposes, it would be easier to beat them if I caught them off guard and alone.

I had my plan, but I was still nervous. One of Theresa's minions, Kendra, was in my first period gym class. So, I showered as quickly as possible, and then I waited. Just as she approached the mirror, I made my move.

"Aaaah!" She screamed only long enough for me to cover her mouth.

"Shut up." I growled as I forced her head back while pulling a hand full of her hair.

Without a second thought, I snatched her to the ground and pummeled her until the bell rang.

When no backlash came from that, I continued my attacks. The last thing I wanted was to get into trouble and be taken away from Mama Mildred, but this had to be done. One by one or two, I'd catch them alone and beat them up. Theresa, however, seemed to always be surrounded and I wanted her most of all. She was the source of all my torture and I figured if she stopped, then they all would.

As I stood at my locker trying to devise a plan for my attack, trouble found me. The force of someone pushing past me almost made me fall to the floor. When I looked up to see that the culprit was Theresa, I was far from surprised.

"Aw, my bad." She said sarcastically as she turned down her nose to me.

"Whatever." I rolled my eyes.

"Whatchu say, Lil girl? Speak up!"

I watched as her much taller, much larger frame, towered over mine. Then I looked around at the faces that were battered and bruised by my own hands; my first thought to attack on sight was quickly abandoned. It would have defeated the whole purpose to only get beat up again.

"All I'm a say is, you BETTA not come to school tomorrow, or else I'm a kill you." She raised and lowered her voice to emphasize certain words before she finished her threat with a firm poke to my forehead.

Something inside me snapped. The only thing that ran through my mind for the rest of the day was her last words to me, "Kill you". Her physical contact to my forehead was nothing compared to her threat, in my mind.

I spent the remainder of the day and all of the night contemplating my next move. All I thought about was protecting my life, but I didn't know why. I was as dead inside as any corpse in the morgue. Even I couldn't understand my sudden need for preservation of life.

Either way, I stayed focused on the task at hand. I barely even spoke to Mama Mildred when I got home that day. I didn't eat. I didn't play. I didn't watch television. I didn't even sleep. So, on the following day, I was still as engrossed in my plan as the day before.

I walked to my locker as I did every morning. But, instead of praying for peace, I welcomed any and every opposition that stood between me and my vengeance.

"This bitch came to school! She must've thought this was a joke." Theresa said as she approached me from behind. "Didn't I tell you not to come to school today?"

Those were the last words she said to me before I sliced her across the chest with my granny's butcher's knife. I didn't eat, play, watch TV, or sleep the day before, because I spent all my time sharpening the blade that I planned to slit Theresa's throat with. I still believe it was an Angel that pulled her out of the way and spared her life, and mine.

She lost a lot of blood and had to spend some time in the hospital, but she lived. Me on the other hand, was treated like a homicidal maniac and was sent to the first children's home that would accept a disturbed thirteen-year-old girl, with my issues. But they had no idea what my issues really were. And despite Mama Mildred's efforts, she was unable to regain custody of me.

The thing I feared the most had happened. I didn't want to be a disappointment to Mama Mildred, but something had to be done. Through the whole ordeal, she continued to show understanding and support, which made the situation even more difficult.

The first person to truly understand me and willing to help me work through my issues with care, was being snatched out of my life when I needed someone the most. First my blood is taken away, and then I'm separated from the thing I yearned for the most; Love.

Chapter Nine
The Angry Piece
(Mother)

After being admitted into the Children's Home, I went from the *teased* to the *tested*. My reputation as a violent offender caused a stir that made people want to see the alleged monster inside me, and with that arose my new adversary, Tootie.

Honestly, she wasn't really the problem. It was the peer-pressure to live up to her prior reputation that caused all the issues. Because everyone seemed to already know my business upon my arrival, it was only second nature for the residents to want to know how disturbed I really was. And since, Tootie, was the resident veteran, she became the guinea pig.

Not wanting to endure the bullying I had just escaped, I decided to use minimal self-control when it came to my peers. I attempted to be as respectful to the staff as I could be, but some of them were as immature as the residents. I felt it best that I kept to myself as much as humanly possible; which proved to be almost impossible.

"So where you come from?" Tootie asked, inviting herself to have a seat across from me at the breakfast table.

I continued to chew my cereal, leaving an uncomfortable silence between us, before I answered. I couldn't believe the audacity of her to interrupt my breakfast with interrogation.

"Home." I replied never allowing her the privilege of my eye contact.

I was well aware that her friends were watching and she had something to prove, but she had no idea what she had walked into.

"Aw, so you a smart ass, huh? Well trust, we gone put a stop to that real quick." She said with a smirk, while snapping her fingers in my face.

Tootie stood, but she only took two steps before I introduced her face to my breakfast tray. All of the people pretending not to be watching gasped and then ran to her rescue. And of course, I was thrown into solitary. I didn't even bother to explain my actions. Something told me that nothing I said would have mattered anyway.

But I have to say that my punishment was worth it. After the incident, everyone had come to the conclusion that I was really crazy. So, they left me alone for the next six months I was there. I'm sure it helped that in my therapy sessions, when given the ink blot test, all the pictures looked like me killing someone different; up to and including my therapist. Not even I realized how mentally detached I was at the time.

In the beginning of my stay, I remained so secluded that I actually started to lose track of the time I spent there. But I eventually realized what they wanted to hear, so that I could get what I wanted, to get out.

"Anna, how are you feeling today?" The seemingly uninterested therapist asked.

She wouldn't even so much as give me eye contact at first.

"I feel good." My attitude was completely contrary to what had become my usual behavior.

"Is that so?" She removed her glasses and gave me her undivided attention.

"Yes, I've really been thinking about my actions and what I can do to change them." I lied intelligently. "I realize that life would be much easier if I learned to comply and find a way to get along with others."

I could tell that the Martha Stewart look-a-like was hardly buying my act, but I continued anyway.

"Well, I think it's wonderful that you are looking forward to a better future. But, how do you feel about the reason you're here?"

"I've been thinking about that a lot and I feel really bad. I feel bad about Tootie too. I've even prayed about it." I laid it on thick as I hung my head in faux shame.

The therapist replaced her glasses and scribbled some notes in my file.

"I'm going to refer that you be placed back in the main unit, under close supervision. If there are signs of any issues, you will be placed back in the solitary unit." She told me.

I was relieved to see that my plan was working. Pretending I was rehabilitated was my first step toward getting out of "baby jail". Luckily, the therapist was uninvolved enough to buy my antics.

So, after my mother regained custody of both my sisters, she finally made it around to bringing me home as well. At least that's how it felt. And I will never forget the feeling that came over me when I saw Mother for the first time in two months.

She only visited me once or twice while I was locked away. But even that wasn't as disturbing as what I saw when we walked to her already occupied vehicle. My eyes burned a whole in her head as she entered the car without reservation.

"Butch, this is my oldest daughter, Anna. Anna, this is Butch, my friend."

"Really Mother?" My eyes were still fixed on her. "I guess he's coming home with us too, huh? Of course he is. I just don't understand how you can even worry about some man, when you barely have your kids back!"

"She's a feisty one, ain't she?" He chuckled.

"We can always turn around and take you back, you know." She threatened.

"It's on you if you want to be known as the woman that put another man before her children." I shot back.

I had nothing else to say. It was inconceivable to me that not only was she continuing to put men before us, she had the audacity to bring him with her to pick me up. Rejection was part of the reason my life was in shambles, and the blows just kept on coming. She had been rehabilitated from her addiction to narcotics, but there was something missing from her life that made being our mother, not sufficient enough for her.

I held my peace for the rest of the ride home. I was so anxious to see my sisters, that I quickly forgot the disappointment that I was used to from my mother. I would have much rather seen them with her instead of Butch. The sad thing was, I wasn't certain that her actions were not pre-meditated in an effort to set me off.

When we pulled in front of our new residence my heart pounded at the thought of seeing Torie and Leah.

"Anna!" Torie screamed as she ran out the door and down the front steps.

She wrapped her arms around my waist and I held her head tight to my chest.

"I missed you so much!" I said squeezing my baby sister. "Where's Leah?"

We both looked up at the screen door at the same time to see Leah watching from inside the house. I grabbed my suitcase with one hand and Torie's hand with the other.

"You been good?" I asked my now nine-year-old princess as we walked toward the door.

"Yeah."

When we reached the door where Leah was standing, I looked at my little sister's unchanged expression. It was clear she wasn't happy to see me.

"Hi Leah!" I tried to sound excited in hopes that it would be contagious.

"Hey." She said dryly, with an embrace that was just as dry.

Leah was physically larger than me, but the fact that I was still the big sister, was never forgotten.

I couldn't understand why after almost two years Leah wouldn't be anything but happy to see me. She acted as if I was the reason we had all been separated in the first place. But that was only the beginning of Leah's ability to deflect a situation.

It amazed me that I could find it in my heart to forgive her for the lies she told when we lived with Dana and Derek, but she seemed to harbor an imaginary resentment towards me. I couldn't help but think that Floyd's unwanted attention caused her to be envious somehow. But I didn't care; she was still my little sister. And I would protect her no matter how she treated me.

Getting comfortable in a house where the only person you trust is nine-years-old, was almost impossible. My mother was no longer on drugs, but that hadn't renewed my trust in her. I couldn't imagine the amount of narcotics that would make the things she had allowed to happen to me, okay with any mother. So, I had to become everything for myself: Mother, father, protector, and provider. I had no idea how much damage it would cause down the line.

Butch, however, found out the hard way that I was not going to allow him the opportunity to violate either of us. Although, he hadn't done anything sexually inappropriate, he found occasion to over-step his bounds.

I had no respect for him for several reasons. First, he was an addict. Which baffled me considering my mother was not. He didn't work. Not to mention, he had no respect for the fact that as my mother's children, we were supposed to come first.

He would bring food home for my mom and himself, while we had to fend for ourselves. But if I made food for me and my sisters, he would insist that I wait on him as well. I never did. In fact, my last refusal prompted a Floyd-like response from him that triggered emotions I didn't realized were still there.

"I'm not cooking you nothin'. This is for me and my sister. You can fix your own food when I finish." I told him.

"Who you think you talkin' to? I'm gone fix that smart ass mouth."

I just ignored the comment and continued to cook. But instead of taking heed to my silence, Butch took offense.

"Do you hear me talking to you?"

The tone in his voice put me on guard. I didn't trust him. I didn't trust anyone. So, the sound of footsteps entering the kitchen was not at all welcomed. I turned to face him holding a rot iron skillet by my side.

"What the hell you think you gone do with that?" He asked as he barreled in my direction.

It was almost like I was watching a movie when the skillet made contact with the side of Butch's head. I mean, I knew I did it, but couldn't quite remember committing the action. Butch left that day. But he managed to come back long enough to rob us blind, never to return again. That was the first time I could remember my body reacting without my mind, but it wouldn't be the last.

One would think, that after giving her crackhead boyfriend a concussion, my mother would be done trying to bring men into our household. But that couldn't be further from the truth.

After being comfortable with just me, my mom, and sisters in the house, I felt for the first time in my life things were close to normal. (Well, minus the physical abuse from my aunt and mother. But we'll get into that later.) Then came the day that I realized for the first time exactly how much I meant to my mother.

"Come on Anna and Leah, ride with me." Mother said.

Torie was across the street at my Aunt Rita's, so I thought nothing of her need to take just me and Leah with her even though we were old enough to stay home alone. We rode for about twenty-minutes before pulling up to a city bus stop. The face that emerged from the shadows, not only caused my heart to pound so loudly I could have sworn it was heard by everyone, it also made me sick to my stomach.

"Daddy!" Leah squealed as she jumped over the seat to hug Floyd's neck.

I couldn't speak. I couldn't move. To be honest, there was a moment when I actually stopped breathing. My hands began to shake and my head started to pound. As tears welled up in my eyes, I remembered my vow to never let him see me cry.

"Hi Baby Girl. Hi Anna."

The sound of my name coming from his lips made my skin crawl. My eyes burned a whole in my mother's head, once again and I refused to respond to Floyd. Everyone, including Leah pretended as if this was a normal situation. But she was so happy to be around someone willing to spend their money, she didn't seem to care about much else.

I began once again in my life to feel like bait. Floyd's offer to give me money during our stop at the store, only assisted in my anxiety.

"I don't want nothin' from you." Were the only words I uttered to him that day.

Once we made it home I was overwhelmed with emotions. I felt afraid, alone, angry, betrayed, confused, and plotted on; among other things. Floyd was like a plague that wouldn't stay away, and my mother was the bacteria that always allowed him to come back.

"Why would she bring him here? Why won't she ever protect me?" I mumbled the questions under my breath.

"Kill him."

I turned to see the source of the voice I was hearing; but I was still as alone in my room as I was before.

"Kill them both." The voice resembled a quiet choir.

I ran to the kitchen as if I was being propelled by an engine and retrieved every sharp knife I could find.

"Kill them both." I heard again louder that time as I ran back to my room.

All I could do to stop from reacting to the commands in my mind, was to mutilate my many cherished stuffed animals. They had been witness to most of the tragedy in my life and I actually mourned them when I was done with their decapitation. But not before I noticed the lacerations to my own hands. I ran to the bathroom sink as blood poured out of my cuts.

"Mama! Anna's bleeding to death!" Torie screamed.

In seconds, my mother appeared in the doorway to help me stop the bleeding.

"Anna, what did you do!?" She screamed.

"Why is he here, Mother?"

The tears that poured profusely from my eyes had nothing to do with the physical pain.

"He hurt me! He hurt us! Why would you bring him here?" I cried.

I knew he could hear every word, but I didn't care.

"Anna, you need to calm down! We are still legally married you know. Even in God's eyes I have the right to give him another chance."

I was five-years-old all over again. But this time I wasn't alone.

A week later

My mom managed to remove all the knives from my room, except for one. I kept one hidden away and I sharpened it on the metal bed frames every chance I got. My bedroom had become my haven. If I was inside the house, then that's where I was; with my knife underneath my mattress. The voices in my head would haunt me, then I'd turn up the radio to drown them out.

Mother, would go to work and leave Floyd at the house with me and Leah. Torie, spent a lot of time across the street at Aunt Rita's and I was relieved. She was one less thing I had to worry about.

Then, after a week of listening to the disgusting sound of him having sex with my mother, he finally made his move.

"Anna, can I talk to you for a minute?" Floyd almost sounded sincere.

"We don't have nothin' to talk about. Get outta my room!" I warned him.

"Look, we can't keep walking around like this." He stepped closer with every other word.

"Floyd, get away from me and get out of my room!"

With that command, I pulled the knife from under my mattress.

"Whatchu gone do with that?" He laughed.

"Take one more step and you'll find out."

I had become calmer than I had been the past week. My hands no longer shook. My heartbeat was steady. And my stance was strong. Once again, I felt I was watching instead of acting and everything seemed to happen in slow motion. As Floyd's foot left the ground, my arm began to swing. It was almost like he stepped into the swing. In my failed effort to slash his throat, I cut him across the shoulder.

The look of disbelief in his eyes said so many things. But his face expressed that he couldn't comprehend that the little girl he had violated for so many years, was standing her ground, and was even willing to kill him so that it would never happen again.

He suffered some blood loss and gained some stitches, but he lived.

I never saw Floyd again after that day. And mother finally realized that a live in boyfriend would never happen as long as I was under her roof.

Chapter Ten
The Altered Piece
(Nikki and NuNu)

Even though Dana and Derek were not able to take care of us full-time, I still maintained a relationship with them and their boys. Over the years, I would spend weekends at their house and join them on family outings. It gave me a sense of what having a real family was like. They seemed to really understand and accept me for whom and what I was. At least what they thought they knew. It was also a temporary relief from the abuse from Mother and Aunt Rita.

One abuse seemed to be traded for another. I couldn't seem to do anything right. There were constant accusations of disrespect or I'd just get jumped on by the both of them for not doing things exactly as they wanted. My life was a trail of broken egg shells. So, my visits to Dana and Derek's allowed me to get away from the beatings and abuse.

Derek, would take me and the boys, Drake and Samuel, to play basketball in the park. I was a natural athlete, so not only was it enjoyable for me, I was actually good at it. Plus, it was away to expel some of the negative energy that was bottled up inside of me.

I was only fifteen, but my mental battle with the voices and loss of time seemed to age me. So, if an opportunity for me to be a child arose, I jumped in head first.

"Y'all gone let Anna beat y'all again?" Derek asked the boys as he refereed the two on one game of basketball.

"It ain't over yet!" Drake, the older of the two taunted.

Just as he finished his sentence, I stole the ball and won with a final game winning point.

"It is now!" I laughed.

"I'll race you to the car!"

Sam took off before I could respond.

Drake and I, looked at one another and sped off at the same time behind Sam. I won the race despite Sam's head start, and no one was surprised.

"That's my athlete!" Derek applauded. "Let's get some ice cream."

Dana, would usually be with us, but that day she was at work. She had also been diagnosed with Lupus, so she had her good days and her not so good days. There were times when she was home, but would be hidden away in her room. Derek, tried to explain her diagnosis to us so we'd understand that her lack of presence was not intentional or personal.

Her absence actually gave me an opportunity to really get to know Derek. Not the father figure Derek or my older cousin Derek, but the Derek that allowed me to drink and smoke weed. Of course, that secret was ours alone.

After Drake, Samuel, and I attempted to wrestle Derek into submission, with no luck, the boys were exhausted. They had played, eaten, and played some more; they were ready for a nap. I took them to their rooms and put them down for the afternoon, then made my way to watch football with Derek.

"You busy?" I asked, knocking on the man cave door.

"Naw, come on in, Athlete."

"What's up?" I noticed the smell of marijuana in the air.

"Want a hit?" He passed me the joint.

I took a hit and sat on the couch across from him.

"Want something to drink?" He offered.

I took a sip of the strong brown concoction and leaned back on the sofa.

"So, what's been up with you?" He asked.

"Not much, just tryna stay out of trouble, but that's easier said than done."

"I'm glad you came over this weekend, it's been a while. I was starting to wonder why you hadn't been around. I was worried about you."

"Aw, Im good. What's been up with you, Dad?" I asked, taking another drag off the joint.

"Well, I'm just trying to make everything easy for Dana, you know. But you don't worry about that; I wanna know how you're doing. What's going on with you and these lil boys?"

"Nothing really, I don't have a boyfriend or nothing."

"You sexually active? You using protection?"

His line of questioning only seemed like innocent fatherly concern to me. But something happened between the hits of weed and sips of liquor that I'm still struggling to comprehend. I don't know if it was a touch, a look, or a suggestive comment; but something he did that day caused me to go to that dark, quiet place and allowed "my protectors" to take over.

When I became cognizant of what was taking place, I was heartbroken above everything else. I couldn't believe that the only man I ever trusted was on top of me, with my legs in the air, treating me like every other pervert I had come in contact with over the years. Then, I thought I would die when he removed himself from my vagina and penetrated me anally. Was it a nightmare? Was it really Derek? These were only a few, among the many questions going through my mind. I had to see his face.

Seconds seemed like hours as I attempted to make eye contact with my assailant through the excruciating pain. But, when I saw his face it was unfamiliar. His body belonged to Derek, but the eyes looking back at me belonged to, PaPa. Pain and rage welled up inside me. I pushed him off and ran away screaming.

My insides felt like they were being ripped from my body. I ran up the stairs so fast, my legs gave out the moment I entered the bathroom. I cried out in pain as the feeling of a dagger cutting me from the inside, hit me once again. Then, when Derek opened the bathroom door I wanted to run, but my legs wouldn't work.

"Anna, what's wrong? You okay?"

The demonic look in his eyes was gone; he was the Derek that I recognized. But, I knew this was the same man that had just violated me minutes earlier, except he acted like nothing had taken place. I was confused and afraid. I didn't know what to think or do.

"I . . . my stomach hurts real bad." I looked at him with confused pleading eyes.

"Do you need something? Let me get you some Pepto Bismol."

I sat there in the middle of the floor trying to comprehend what was happening. Is he trying to make me think that the reason for my pain was just a figment of my imagination? I knew I hadn't imagined all that had just taken place. My pain was real. My fear was real. The betrayal was real. But just as real as all of those things, so was my confusion.

I knew I had lost time again, but this was crucial. There were so many questions I needed the answers to. The most important of them was; why? Did I do or say something in my *absence* that made him feel justified in his actions, or had he been a pedophile the whole time? Was this the first time, or had he taken advantage of my separated psyche before?

I didn't know, and I wasn't going to ask. I just obliged his performance and took a dose of Pepto. But for the remainder of the day, I stayed as far away from Derek, and as close to the boys as possible.

My stomach did somersaults at the thought of hurting Dana. I replayed the conversation I would have with her a million times, but when she walked through the door, the words descended down my throat and hid in the pit of my stomach. But this was the same woman that saw me at my worst psychological state and there was no hiding that something was wrong.

"Girl, you been fidgety and nervous ever since I walked through the door; what's wrong with you?" Dana asked.

"Nothing."

No matter how hard I tried, I couldn't look her in the eyes. Then, I had no choice. She stood right in front of me and gently grabbed my shoulders.

"Anna, tell me what's wrong."

She was just as concerned as the day I first arrived at their home years earlier.

"You can talk to me baby." She consoled.

I couldn't hold it any longer. The words poured out with my tears and I told her everything. Well, almost everything. See, I told her about the marijuana and the liquor and the rape, but what I didn't tell her is who it really was.

"It was my boss at work." I lied.

She put her arms around me and consoled me even further.

"I'm so sorry this keeps happening to you."

Dana held me in her arms and shed tears of empathy. I made her promise not to tell my mother and I promised that I would bring the situation to the attention of a superior at work.

I went home that night and I couldn't sleep, I couldn't think, I couldn't even eat. So, I wasn't surprised when my concentration in school the next day was non-existent. I thought that telling my story would help to ease the guilt of keeping this a secret, but I was still living a lie. My conscious knew I hadn't told the entire truth and it ate at my soul as if it were all a lie.

My teacher's voice was inaudible as the flashes of Derek's possessed face flooded my memory. I grabbed a sheet of paper and began to write. If I wrote the truth out on paper, then it would be released from my possession. That's what made the most sense at the time. That is, until my teacher snatched the paper from my grasp before I even realized what was happening.

"Ms. Jeffries, please give that back to me!" I pled.

I had been so engulfed in my thoughts and in my writing, that unbeknownst to me, my teacher had attempted several times to get my attention. So, assuming I was passing notes, Ms. Jeffries decided to interrupt the activity that had taken my attention away from her class.

"This is not the time or the place for this." She said holding the paper in the air.

My eyes followed every sway in hopes that she would return it safely to my possession.

"But . . ."

"But nothing! Pay attention young lady."

I watched as she went back to her desk and placed the paper in her drawer. There was a flood of relief that showered over me at the thought that she may actually dispose of the note like she did everyone else's. So, I attempted to focus on my work.

"Anna, can I please see you for a moment?" Her voice was no longer accusatory.

I looked around the room at the other unsuspecting students, and then finally at the crumpled paper in her hand. A feeling of hopelessness and intense anxiety rushed over me.

"Yes Ma'am."

The moments after that seemed like an eternity. We walked into the hallway and Ms. Jeffries eyes were welled up with tears.

"Anna, is this true? Did this really happen to you?" She asked with the most sincere eyes I had ever encountered from her.

I couldn't even answer. The magnitude of the weight of everything came crashing down all at once, and I broke down. She called my mother; which led to a trip to the emergency room. The doctors substantiated my vaginal and anal injuries; which led to the involvement of the police.

To say that I was embarrassed was a severe understatement. I was forced to face Dana after lying to her initially. In my small mind, I was protecting her somehow. It seemed I spent most of my young life protecting everyone, but there was never anyone there to protect me; at least, no one outside of my own mind.

Even then, Derek lied about the incident. He acted as if I hallucinated it all and swore he never touched me. That is, until the D.N.A. results came back and proved that "touch" was the least of what he had done. But even D.N.A. didn't help my case. He then claimed that it was consensual and I threw myself at him. And despite all the physical evidence, there were no charges filed because of my "troubled mental history".

After the incident, I went through extensive therapy and I was diagnosed with a plethora of mental conditions. At the top of that list was Schizoaffective Disorder and Severe Dissociative Disorder. It actually helped to explain what was going on in my head; the voices, the loss of time. But to everyone else I was just crazy. And it gave my mother the opportunity for an extra income. Sometimes I think she intentionally tried to drive me crazy so she wouldn't lose my check. One would have thought with a diagnosis so severe that the beatings would have subsided. But I was wrong, in fact, they got worse.

I found myself losing time more and more often. Then one day, I saw them for myself; Nikki and NuNu. Disbelief swept over me as I watched my reflection in the mirror transform into two women very different from myself. They seemed to look in my direction, but I felt invisible.

"Bitch, you always tryna kill somebody!"

They spoke to one another while admiring themselves in my reflection.

"So what! You the one that gotta fuck everybody! Them niggas betta not touch me, not if they know what's good for 'em."

"I have to; she can't handle it anymore, look at her."

Just as they began to look into my soul, they disappeared as suddenly as they came.

"I've officially lost my mind." I said aloud to myself.

The truth was, I started to lose myself the first day Floyd violated me. The direction of my life changed that day. But I believe that my "protectors" began to surface when I realized that there was no one else to protect me, including Mother.

Still guilt ridden from the pain I had caused Dana and her boys, I couldn't get over the fact that what Derek did to me was my fault somehow. Our relationship was never restored, not even before she died a few years later due to complications from Lupus. I felt too much guilt to see her when she was in the hospital. Not only did I think I was the last person she wanted to see, I didn't want to upset Samuel and Drake any more than necessary.

I never got a chance to talk to her or explain myself. I harbored guilt over the fact that I truly believe she died of a broken heart, by my hands. I prayed that she found it in her heart to forgive me, because I didn't know if I ever would. I'm so sorry Dana.

Chapter Eleven
The Battered Piece
(Aunt Rita)

A few years had passed and my existence hadn't become any less miserable. I felt like less than nothing and I was being treated even worse. The beatings had become considerably more violent. Even after being told by doctors that I was unaware of a lot of my behaviors and that physical reprimand would only make my condition worse, my mom and aunt continued with their "discipline", as they would so eloquently put it.

The abuse triggered severe psychotic episodes that would land me in the psych ward of several different hospitals. I would vividly describe the abuse at the hands of the orderlies, but the drug induced haze that they always took advantage of, blessed me with the gift of not having to remember details. Thank God. Because what I did remember was far too much for me in my state.

I started to spend more and more time away from home; it seemed to be the unhealthiest place for me. I felt hated from everyone except for Torie. Leah, was in her own world smoking, drinking, and having sex. However, no one seemed to notice all the dirt she did. My aunt and mother always focused on me, and seemed to search for reasons to disapprove of any action that would trigger violence from either of them. From the way I was treated, I must have done awful things when I wasn't aware of my actions. At least, I hoped there was a reason that an aunt and mother would be so sadistic, besides money.

Once my mother found out about my diagnosis, everything I said became a lie. Or I was just all together crazy. Mother would escort me to appointments just to tell them things that would assure they'd declare me incompetent, while she appeared to be the classic victim/mother of a mentally ill child. Thinking back, it had to be some form of Munchausen Syndrome. After almost eighteen years, she was still starved for attention. But, at that point, it was at the risk of my sanity and most of all my life.

Mother made it a point to keep me away from anyone she knew would show me love and affection. Mama Mildred, my Aunt Renee, and my cousin Jeanette were off limits to me no matter how much they tried to spend time with me. She would always block their attempts by telling them I was in trouble or any outlandish story that would keep them away. My cousin Jeanette even attempted to take me to Africa with her when she moved, but Mother wasn't having it. She was more concerned about receiving my check than she was about my well-being.

I wasn't completely alone, I spent time with my friend, Claude. He was mentally disabled, but he was safe and I trusted him. He had a child-like mentality that caused me to even be protective of him. He was about seventeen, but he had the purity of a seven-year-old.

We would hang out in our neighborhood in Webster Grove, when there was actually a time in my life when I was not afraid to be around people. I had a hard time with trust, but I was able to be in the presence of others without anxiety. It wouldn't be long before all of that would change.

It was a beautiful, sunny day when Claude decided to stop at one of his friend's houses. Despite his speech and child-like persona, Claude was pretty popular in the neighborhood. I sat outside on the concrete steps and listened as Mary J. Blige's "Real Love", blasted from the house next door.

"Real love, I'm searching for a real love; someone to set my heart free. . ." I did my best Mary J. Blige impression.

"Damn Babygirl! Was that you singing?" I heard a voice from next door say.

As my eyes searched for the source, he appeared seemingly out of nowhere.

"Um, yeah, that was me." I blushed.

"I like your voice. I might need you to drop some background vocals for me." He said.

"Background vocals?"

"Aw, damn Baby, I'm sorry. My name is Jerome. I rap, they call me J. Romeo." He extended his hand.

"Hi." I grinned in his direction while he gently shook my hand.

He was charming. And just as he promised, I was in the studio singing background vocals that at that time made me feel like a superstar. But since hindsight is 20/20, I know now that my musical exploits were just that, exploits. I sounded terrible. In my right mind, that would have been a prelude to the truth. But, I wanted so desperately to be loved, accepted, and out of my situation, that I think I would have done just about anything.

Before long, Jerome and I became an item; I spent more and more time at his apartment. Because of his rapper-hood dreams, he seemed to have a revolving door. People were constantly in and out; it was like a never ending party. But there was one guest that seemed to frequent the apartment more than the others; Kesha.

Jerome told me that they were friends and they grew up together, so I thought nothing of it. I figured if she was going to be a permanent fixture in his life, then I had no choice but to accept her. I continued to play the woman of the house, as long as it meant spending time away from the hell that was home.

I had enlightened Jerome and my newly found friend, Kesha, about the abuse that I endured at the hands of my own family. They showed empathy. Jerome even suggested that I move in permanently. I got the cable cut on in my name and I made plans to get my belongings from my former residence.

My stomach did flips when we pulled in front of my mother's house and it must have shown in my expression.

"You cool?" Jerome asked.

"You want me to go with you?" Kesha followed up.

"Naw, I'm good. I'll be right back."

I made my way into the house and began to pack some clothing. I was in the basement when I heard the commotion coming from upstairs.

"Where she at?!" Aunt Rita spat.

"Downstairs." I could hear my younger cousin Steebo snitch.

The sound of her stomping down the stairs could have been compared to demolition.

"What the hell you think you doin'?"

I looked around as if to insinuate the obvious.

"I'm gettin' my stuff?"

"Why would you get my sister's cable cut off?!"

"Cable?" I was confused.

Aunt Rita took no time showing me who was boss. She never did. She always made her best effort to try to break me.

Slap!

She slapped me so hard, my ears rang. All I could do was hold my face.

"Steebo, go find me a bat! I'm about to kill this bitch!"

Although, Steebo found pleasure in taunting me and degrading me with Leah, he wanted no part in what was about to take place. Like a mad woman, my Aunt Rita searched for anything she could use to hurt me. It wasn't long before she returned with a metal pole and an additional broom-stick like apparatus.

Whap!

The first hit stung and felt like bones breaking in by back. I screamed in agony, but she seemed to get some enjoyment out of my pain. She continued to beat me as my baby sister, Torie, watched in horror.

"You think you grown? I'm gone beat you like you grown!"

My screams could be heard outside. Jerome and Kesha weren't sure if they should intervene or call the police. I managed to get some of my belongings, but not before the police arrived. I was taken to a hospital and once again treated like everything was my fault, due to my mental history.

I later found out that my mother had illegally used my name to obtain cable. So, when I had my cable installed at my new residence, hers was disconnected. Once I was able to sit back and analyze the madness, I realized I was being punished once again for exposing the truth.

After completely moving in with J, I thought it was strange how much time Kesha spent with us. But, I had nowhere else to go, so I didn't want to make any waves. Things became abundantly clear, when he came to us with a proposal.

"Y'all say y'all love me right? Y'all my riders?" Jerome asked unexpected.

"Yeah." We both answered, giving one another the side eye.

"I want y'all to have my babies."

If I wasn't so gullible and desperate at the time, I would've seen this coming from a million miles away. But, because I would fall for anything, we wound up in a semi-threesome situation. Basically, we lay there while J took turns having sex with us both.

It wasn't until Kesha became pregnant, and Jerome started to use me to get money for pleasuring other men, that I realized I was set up from the beginning. He was never mine. Jerome had been Kesha's from the start. And only because of her empathy for my situation and what Jerome thought I could bring to the table, was I able to stay in their situation for as long as I had.

He was very subtle in his approach, at first. It began with compliments from his friends. They would say things like they wish they had someone like me. It was flattering and a far cry different from what I had become accustomed to. Then it happened. Everything that Floyd put me through, brought me to the moment that showed me my life's worth.

"Let me holler at you, Anna." Jerome said, pulling me to the side. "Aye look. My boy just got outta jail and he like you. I want you to hook him up." I couldn't believe what I was hearing.

"So, I'm your prostitute now?" I asked with tears in my eyes.

"I didn't say that. But you ain't bringing nothing else to the table. Where you gone go?"

The sad, gruesome reality was that he was absolutely right. At least he let me decide what I would or wouldn't do. Plus, the more sexual favors I performed, they seemed to numb me. That period of my life is full of holes and lost memories. Then one day, even further exposure of my illness was brought to light, during a heart-to-heart with Kesha.

"Anna, what's really wrong with you?" She asked.

"Whatchu mean?" I was completely oblivious as to what she meant.

"I mean, how you act sometimes. You know, like it's not even you." She tried to explain.

"I don't know whatchu talkin' about, Kesha! You tryna make me think I'm crazy like my mama and my auntie?"

"No! Look, you do some strange stuff that I don't understand. I just wanted to know why, that's all."

"But, I honestly don't know what you're talking about." I admitted.

Kesha sat across from me and gave me direct eye contact.

"Anna, you talk to yourself . . . a lot. And at the drop of a hat, you will just start acting like whoever we're watching on TV. You talk about killing and committing suicide. Anyway, I though after we got you away from your family that you wouldn't keep threatening to kill yourself?"

"I don't remember doing that. Kesha, I'm sick, and without my meds, I don't remember a lot of stuff." I looked to the floor in shame. "I hear voices . . . and I have other people living in my head."

"What?" She was perplexed.

I tried to explain as much about my illness as I could, but I didn't know how I felt about admitting out loud that I was crazy, but it was strangely liberating. I felt close to Kesha at that moment, but I never felt that close to her again.

She then told me about the first time she encountered one of my alternate personalities. Apparently, while she washed my hair and prepared to flat-iron it, I transitioned into a four-year-old girl. To this day, I can't remember what the little girl's name was. She said I told her that I was afraid that they would get rid of me when the baby comes. I didn't believe her until she showed me an entry in my journal that had child-like handwriting, with letters and numbers inverted. Then she showed me the letter her mother found in a notebook I left at her home.

The letter detailed plans to poison Kesha, then Jerome, and finally myself, then blame it all on Kesha. My illness was slowly progressing due to my mother's refusal to cooperate with getting my meds. I quickly began to realize that with Kesha being pregnant, she and Jerome were becoming a family. And who really wants a clinically insane person around their child? But, until they made their decision to cast me off the island, I would do whatever it took to stay.

I was the hostess, the cook, the maid, and the resident piece of ass. J was sure to keep me intoxicated enough to be compliant. The danger of taking street drugs with my mental condition, wasn't evident to me at that time. And the crack-laced blunts he gave me made me want to smoke only what he had to give me. By the time I realized I was being drugged, it was all I wanted.

Then came the house party that changed my life. Jerome was hosting a get together, and I was the hostess. I cooked the food and made hors d'oeuvres for his guests. Once they arrived, I made sure everyone was fed and they're cups stayed full.

"Hey Baby, you did a good job tonight. I appreciate it." Jerome complimented.

"Thank you." I smiled.

"Why don't you get off your feet for a minute? Here, enjoy the festivities."

He handed me a cup full of some alcoholic concoction and a laced blunt. I was flattered that he thought enough of me to give me a break. But I should have known that Jerome does nothing without a motive.

Four hours later, I woke up naked with semen and dried up saliva all over my body. I was disgusted. Not only had I been drugged, I had apparently been had by almost every man at the party. I watched through a groggy haze, as men handed Jerome money and slapped him five as they walked out the door.

Had this whole party been to make money off me? I had been set up by my mother my entire life, and the feeling was all too familiar. Did I have too many rules? Is that why he felt the need to drug me? I felt violated in every way possible. But the sound of J's voice kept ringing through my head.

"Where you gone go?"

I had no one and I had nowhere to go. So I picked up the clothes I could find and went to the bathroom to wash off the shame.

Two Months Later

"Kesha, can I talk to you?"

"What's up?"

Our friendship seem to become more and more distant, the further along she was in her pregnancy. But I figured that I was still able to confide in her.

"Look."

I handed her the third positive pregnancy test I had taken.

"So, what this mean?" She was cold.

"It's kind of obvious; I'm pregnant."

"By who?"

That seemed to be the only question she truly wanted the answer to.

"To be honest, I don't know. Especially after that party a couple of months back." I had to admit. "But please don't say nothin'. I want to tell J myself."

She didn't respond. But the look in her eyes told me that whatever bond we shared, had diminished tremendously since the day of my transparency.

A few days later, Jerome came to me with what felt like a hostel interrogation.

"You got something you need to tell me?" He asked.

"Well, since you asked; I'm pregnant." I said bluntly.

"By who?"

I was becoming tired of that question. I hung my head in shame, once again.

"I don't know. It had to happen at the party."

"You know you can't stay here, right?" He dropped a bomb with the magnitude of Hiroshima.

"What?" I couldn't believe what I was hearing, once again.

I couldn't understand how he could rescue me from hell, and then so easily throw me back to the wolves. Then, when the police came to escort me out of the apartment, at Jerome's request, reality hit me like Mike Tyson. He could care less about me once I became of no use to him. He manipulated my situation for his own gain and I had become damaged goods.

Without seeing a dime of the money that I degraded my soul for, I packed the little belongings I had and did the walk of shame through my mother's front door. My internal and external battle to get away from my abusers, took me on a complete 360 degree journey back to where I started.

I didn't know who had fathered my child, but instantly my baby had become the most important thing in my life. Battered or not, I would do anything to protect the life growing inside me.

Chapter Twelve
The Protective Piece
(James)

The shame and embarrassment that I felt having to go back home, was even more depressing that the situation itself. And to make matters worse, Jerome continued to lead me on as if he cared. He even agreed to help me take care of my baby. But false promises only made my hope diminish.

My mother didn't seem to care much that I was carrying another life. In fact, her tolerance for me seemed even less than before. Maybe, it was the fact that Leah also happened to be pregnant, and the thought of having two teenage daughters with-child, seemed too much like parental failure to her. Even still, her anger seemed to kindle towards me and me only. Anything and everything I did seemed to trigger violence from her.

"Why would you throw that girl's medicine away?!" Mother screamed.

"What medicine?" I asked.

"She said it was in there before you took your ass in the bathroom!" She continued to rant.

"But Mother, I don't know what you're talking about."

I tried to keep my tone as neutral as possible, because the look in her eyes said she was waiting for a reason to swing.

"I'm so fucking sick of you!"

Whap!

That was the first hit. But that hit was followed by a barrage of fists flying.

"Mother!" I screamed.

"You. Always. Over. Steppin'. Your. Bounds!" She threw a punch with every word.

"Momma, stop! You can't keep hittin' her like that, she pregnant!" Leah came to my rescue.

To my surprise, Leah and I had actually become closer during our pregnancies, and she was very protective of me.

"She probably thought it was trash, Momma. Look!"

At that moment, I remembered entering the bathroom and disposing of a piece of clear saran wrap, with what appeared to be Vaseline residue on it.

"I don't care! If it wasn't hers, she shouldn't have touched it!" She seemed unreasonably livid.

Just as my mother prepared to swing again, my aunt came running in the house.

"Trina, stop! She pregnant." She had to be reminded again. "If the police come, they gone take you to jail."

As sad as it was that Aunt Rita's only reason for saving me was to save my mother from incarceration, I was still relieved. However, my mother's decision to send me to a shelter was not at all the conclusion I thought she'd come to.

She had to know that the anxiety of living with strangers was enough to trigger my illness. But she made it painfully obvious that she didn't care. She couldn't deal with me and that was enough for her to send me away, even after every effort she took to make my life a living hell. I was only four months pregnant when she left me to fend for myself. I felt like she waited until she was sure that I had no one but her, then she threw me away, again.

I spent the next excruciating four months, alone, in a homeless shelter, where I was misused, abused, and taken advantage of.

There were women that would pretend to befriend me so they could steal from me. They'd take anything; money, clothes, shoes, identity. It didn't take me long to adapt to my environment and place trust where it belonged; nowhere.

Being alone and with-child made my depression worse than ever. I had no one and nowhere to go, but I was now responsible for another life. In my mental state, I wasn't even sure if I was stable enough to care for an infant. I would never in a million years hurt my baby, but I, wasn't me, half the time. Not to mention, I still didn't know who fathered my child.

I had considered adoption on several occasions. Then one day, a news station came to the shelter to discuss a law that had been passed. The law made it legal for mothers to leave their babies at an authorized facility, if they were unable or unwilling to care for them.

I was vulnerable and pregnant when the local television news reporter approached me and asked my opinion on the matter.

"How do you feel about a law that gives mothers the legal premise to, what some would say, abandon their babies?"

The lights from the camera made me nervous, but there was something inside of me that took advantage of an opportunity to cry out for help.

"I think it's a good thing. At least girls won't feel like they have to hurt the baby or throw it away."

"As a young, pregnant woman, living in a shelter, what are your future plans for you and your baby?"

"I plan to give my baby up for adoption." That was the first time I said it out loud.

I almost threw up at the thought of what could happen to a child abandoned in the system or adopted by sociopaths. For the next few weeks, I thought a lot about what the future held for us; me and my baby. I didn't know what I would do or where I would go, but I knew I had to come up with a plan. I was tired of living at the whim of another person.

"Anna, you got a phone call." The female staff member informed me.

I hadn't received a call or visit, so I couldn't imagine who would be contacting me, besides my mother.

"Hello?"

"Wuz up, Anna?"

I couldn't believe the voice I was hearing.

"What do you want, Jerome?"

"I saw you on TV talkin' about giving up the baby. And they said you was in a shelter and shit." He said.

"Yeah, so why you worried about any of that?" I felt there was an ulterior motive.

"I just want you to know that no matter what, that's my baby. I mean, I'm responsible regardless, you know?"

"I guess."

I didn't take much for him to activate my vulnerability with just the thought that someone cared.

"Keep in touch and let me know when the baby comes."

There was never an offer to give me a place to live, but at least there was a glimmer of hope for support of some kind. But I knew deep down that there was no way that Kesha would allow me back into their lives and home again.

I spent the next couple of months in the shelter, and my mother agreed to let me come home right before my baby was due. Sadly, I think it was because she thought about the money she could receive. J, stayed in touch and ensured me that he would be there. When I went into labor three weeks early, and he was there, I can honestly say that I was surprised. What I wasn't surprised about, however, was his obvious need to see if my baby truly belonged to him.

When he was sure that my daughter did not resemble him or his daughter with Kesha, getting him to sign the birth certificate was impossible; even if my daughter did have his last name.

Chelsey, was the most important thing in my life. But my mother still belittled me at every turn. No matter how much I cared for her or how attentive I was, she cried. As far as my mother was concerned, it was all my fault. She even threatened to call protective services on me. That confused me, considering my sixteen-year-old sister also had a baby. But there was apparently no reason to question a woman that had neglected and abused her children; at least in her eyes. But I digress.

After not being able to console my obviously unsatisfied infant, I took her to the hospital. I knew something was wrong, but I was not prepared for what the doctor told me.

"Ms. Frazier, your daughter suffers from severe acid reflux disease. Now, this condition has the capacity to be extremely debilitating to adults that suffer with this disease. So, an infant so young can only experience even worse symptoms. At this point, the acid is destroying the protective lining of her delicate stomach and is eating away at her esophagus."

"So, what does that mean?" I asked.

"It means that we need to keep her here for further testing and observation. But as far as what the future holds, it truly depends on the progression of her disease. And it's sad to say, but at this rate she may not make it to her second birthday.

What else could go wrong in my life? I finally have one person that will love me unconditionally, and now I'm being told that her health is unpredictable. Being a mother was one thing, but being alone made the situation seem diabolical at the time. I loved my baby, but what was I going to do?

For the next few months, my life was an uncontrollable roller coaster. Everything in my life was out of control: my mental state, my stability, my daughter's health, and even my relationships. I was at my breaking point.

"I'm so sorry! I messed up. This is not the way I wanted your life to be!" I cried aloud to my unsuspecting infant.

I looked over at my sleeping baby that was finally home for what I didn't know then would only be a few weeks.

"Don't cry, baby girl. I got this." I heard a male voice in the room.

I looked over at my still sleeping baby and then looked around the room to be sure I was alone. Convinced that I must be hallucinating, I went to the bathroom to splash some water on my face.

"Get it together, Anna." I said to myself as I looked in the mirror.

I went back to my room and tried to collect my thoughts. When I stood in my bedroom mirror, I could see the hopelessness in my eyes and the tears started to flow once more.

"I told you I got this, baby."

I heard the voice again. But that time, I could see the source. I stood in the mirror as a male figure addressed me. He was light-skinned with a thin mustache and he was gorgeous. But most important, he showed compassion for me.

"That's my baby. I'm yo' baby's daddy. You don't have to worry about nothin', James got you."

Real or not, I felt secure. I felt that someone actually cared for me and my baby; James made us a family. No matter what happened, no matter how bad things got, he was there to comfort me. Even when doctors told me that my daughter's condition was worsening, James was there; keeping me calm, consoling me, and reminding me that I wasn't alone.

That time in my life was hectic and confusing. So much so, that the personification of James in my life made delving into homosexuality of no effect. Especially since I believed he was meeting women without my knowledge anyway. I adapted to and indulged in women like I had everything else in my life. I seemed to be watching a movie that had lasted twenty years.

I was in a relationship with a woman twenty-two years my senior, for almost a year, before my morals began to kick in. I literally felt mortal danger for the way I was living. Refusing to succumb to another person, I had my own place, so we didn't live together. But in my eyes, the relationship itself was wrong.

I made the decision to part from my girlfriend, Alisha, after seven months. Although, I was taking care of her after her accident at work, her friends and family insisted that I was using her. I was offended at the accusation, but we managed to part ways amicably.

My baby's health was still sketchy and I began to turn my sights to God. In my selfishness, I knew the only reason for my sudden spirituality was Chelsey's condition. I mean, I loved God, I think. But, I felt like after all I'd been through, he owed me something.

Soon after Alisha and I separated, I started to date Kevin. He was the maintenance man in my apartment building. He seemed nice enough and he took special effort to pursue me. We eventually began a relationship that lasted seventeen long months.

The first sign of trouble should have been his insecurity. As soon as he found out that I had been in a relationship with a woman, he was immediately intimidated. He started to show signs of jealousy and possessiveness from that point on. I found out that he had an ex-girlfriend that left him for a woman, so just the word lesbian was traumatic for him.

I later discovered that he was also a womanizer and a liar. He turned out to be about eight years older than he originally told me, and he had six children instead of the two he claimed, at the beginning of the relationship.

Things seemed to take a turn for the worst when my mother got him fired from his job. She was so upset that she no longer had control over my life and my money, which included me and Chelsey's disability checks, that she became desperate and would do almost anything. Part of that was reporting Kevin for dating a mentally incapable tenant.

"After that, he became violent toward me. It was as if I was the cause of every problem in his life. Yet another demon had come to haunt me and even though I was in my own space, I felt I had nowhere to run. It was those times that James fought for me the hardest. I honestly can't recall all of our battles. But what I do recall are the days when I wondered why he looked worse than I did.

Nevertheless, Chelsey stayed protected. Through the fighting, the arguing, throwing, and whatever confusion came with dealing with a man-child, I refused to let anything happen to my baby. I would die for her and I couldn't understand why there was still no one, other than James, Nikki, and NuNu, willing to die for me too.

Chapter Thirteen
The Married Piece
(Jermaine)

Ring! . . . Ring!

"Hello." I answered.

"What's up, Anna?"

The voice on the other end of the phone gave me as much peace as it did panic.

"Jermaine?"

"Yeah, it's me. How are you doing?" He asked.

I could tell from his voice that he already knew the answer to that question.

"Um . . . yeah, I'm cool."

"Who is that?" Kevin questioned as he walked in the living room.

"Just a friend of mine."

"What friend?" He interrogated.

"Look, Jermaine, I gotta go. I'm in a relationship, so don't call here anymore."

I hung up the phone before Jermaine could say another word.

"So, you got niggas callin' here now?"

"No. I didn't give him the number. Besides, he's just somebody I grew up with." I tried to explain.

But this, just like everything else, triggered an altercation. For once, his reaction may have been valid. Jermaine was a childhood friend, true. But our relationship was much deeper that just friends. He was the one person that knew everything about me, and loved me anyway. That fact, made me afraid of him and caused me to run away every time we came in contact. His unexpected call triggered emotions that I had long suppressed to protect my own feelings.

The days after that were miserable, to say the least. Kevin acted out like a juvenile delinquent in a grown man's body. He became even more disrespectful than before, with no regard to the way he spoke or acted; continuing to blame me for everything.

I would be the sponge of accusation as long as it meant no anger would be taken out on my angel. I would take the physical, mental, and verbal abuse to my grave, but the last straw was one that I'm certain Kevin would never forget.

Chelsey was my miracle child at three-years-old, already surviving a year longer than the doctors diagnosed. She was everything to me and I let her know that every day she lived was a blessing in my eyes. My angel had everything she wanted and needed.

One day, as I took a nap, my alleged fiancé was supposed to be caring for my daughter. I heard the interaction between the two and decided to stay in bed and listen. To this very day, I'm so glad I did.

"I'm hungry." Chelsey told Kevin.

I listened to the silence and it became uncomfortable for even me.

"Mr. Kevin?"

"What?!"

The volume of his voice cause me to jump from surprise.

"I'm hungry." Chelsey said hesitantly.

"Get yo' ass back upstairs, and wait for yo' momma to wake up and feed you!"

I became hot from the inside out. I was out of the bed and down the stairs before Kevin's rejection could set in.

"Baby, go upstairs and close the door. Momma's gonna feed you in just a minute. Okay?" I told her.

"Okay Momma." She agreed with innocent eyes.

The bedroom door barely closed before I lost complete control of myself. I instantly had a flashback of Floyd treating me like an adolescent whore. The line had been crossed.

"Are you fucking crazy?! Don't you ever talk to my baby like that! You treat her like you hate her and I refuse to allow you to stay here! You gotta leave. You can't stay here with my baby . . ." I rambled off my distain for his behavior.

"I ain't goin' no mutha fuckin' where! You got me fucked up!"

His usual resort to violence was no surprise to me. However, he was not prepared to deal with my protectors. I honestly can't remember the whole ordeal, but I know he went at least a round or two with each one of my alters. Flashes of the actual scuffle remain, but what I remembered most were his threats to kill me and my daughter. What happened after that, can only be told by Kevin and God. Needless to say, he never made good on his threats, and that day marked the end of our relationship.

Pretending to be someone I wasn't only caused me more mental anguish. Plus, I was at a point in my life where I refused to continue to be abused, by anyone. There were only a few people in my life that I felt genuinely loved and accepted me for who I truly was. But my life was so full of rejection and disappointment that I continued to run from the love and acceptance that I deserved.

Jermaine, was one of those people. I told him about my life and my mental health, and he still wanted me. I could tell that his feelings were real and he wanted nothing from me except for my love. I was done putting my heart and my life on the line for anyone else that didn't deserve it.

My Aunt Renee was the only way I knew for sure to contact Jermaine. I was certain that she was the source of the contact information Jermaine had for me as well. She was also the only one in my family that wouldn't try to circumvent any and all contact between us, for fear of being exposed. Just as I thought, Aunt Renee had all the information I needed and I went to get my man, have my son, Major, and get married.

Our relationship was different from any that I'd encountered. First, we've known one another for most of our lives. And second, but most importantly, he accepted me and my daughter. Plus, he loved me for who I was; personalities and all.

He actually developed relationships with all of my alters, and so did my children. It was strange at first to hear him talk about them in detail. I had to truly admit that this is who I was. But there were times when jealousy would set in because of some alters taking advantage of him; but I was inclined to believe otherwise.

"So, do you like her better?" I asked as we sat in bed.

"What?" Jermaine was confused at first.

"NuNu? You know what I'm talking about."

There had been more than one occasion that I had come to my own mind, and it was obvious that I had been sexually active.

"Baby, why you trippin'? It's still you."

"See, that's what you don't understand. It's not! It's cool for you, because you get what you want; and probably exactly how you want it. But put yourself in my shoes. Someone that's been abused and taken advantage of sexually. It's like I'm waking up after that night I was drugged and gang-raped over and over again."

Jermaine was not a man of many words, but his face told me that he understood. His actions however, said that he over-stood. Our sex life was starting to diminish and we needed help. My psychological state was burden enough and coupled with my little girl's failing health, seemed to magnify our problems.

Trust, was still a huge issue for me as well. So, when I saw similar dysfunction amongst my in-laws, it triggered alarms of my own upbringing. I knew he loved me, but Jermaine's mother had a way of debilitating him so that he would not develop responsibly. I believe it was her method of control. It set off an obsessive compulsive side of my illness that drove us all crazy. As a result, I allowed my therapist to hypnotize me in hopes that I could make some breakthrough in my diagnosis and recovery.

"Why do you want to do this?" Dr. Stuart asked.

She had been managing with my illness for the past eight years. Before, I barely wanted to admit that I had a problem. Now, I wanted to face them head on.

"It's for my family. They see things that I don't. I put them through things I'm not even aware of and I want to understand, for them. I'm tired of being crazy and blind." I told her.

"Well, I have to warn you, coming face-to-face with unknown parts of yourself can have adverse effects on your condition, or it could help. It's literally a crap shoot. There is nothing standard, other than medication, about the treatment of your condition." She explained.

"I understand. But I need to do this, now."

What my psychiatrist didn't know, was that I was dealing with more than my mental well-being. I was definitely worried about my family as a result of my mental issues, but I was battling physical illness as well; HPV, Human Papilloma Virus.

I made light of my Cancer diagnosis at first. I suppose it was because everyone else had treated it like it was nothing for the past five years. But that was far from the truth. The disease was doing more to my body than anyone realized, even me.

Per my request, Dr. Stuart performed a video recorded hypnosis. I was astonished at the changes that took place before my eyes as she played back the recording. When I witnessed my alternate personalities in action for myself, they actually looked like other people. But to watch myself act as if I was at least three other people was disturbing to me. I mean, I knew they were there, but just the epiphany that the voices are no more than a misplace association in my mind, frightened me. The fact that I had no control or recollection of them, was even worse.

I had taken medication to suppress them for years. But the stresses in my life triggered them; medication or not. I thought seeing them would help me gain control, but I was wrong. It made me even more paranoid and afraid. Then the day came when the truth was revealed to me.

I had a hair appointment in downtown St. Louis. My family and I lived in St. Peters, which was literally at the opposite end of town. By that time, I was completely untrusting of strangers. In fact, my children weren't even allowed to visit my mother without constant phone calls. So, going on an hour long journey to a place I was completely unfamiliar with, was a true testament to my will.

Once downtown, I became confused by all the cut-off and one-way streets. I was lost with no cell phone or means of communication to anyone I trusted. I tried to turn down different streets until I found a familiar street. But, unbeknownst to me, I was driving myself deeper into a maze. There I was, on a dead-end downtown street, surrounded by high-rise buildings.

It felt like the scene straight out of a horror movie. I was alone and for some reason, it seemed darker than before. I had no clue where I was or what turns I took to get there. Then there appeared a man, seemingly out of nowhere. He was well-dressed and didn't appear to pose any threat; at first.

"Excuse me, can you please tell me how to get to Olive Street?" I asked him.

He looked around as if to gage his surroundings. In the blink of an eye, he had a gun pointed at my head.

"Get out! Get on your knees and suck this dick." He ordered.

I was on the verge of full-on panic attack. That, added to my anxiety, was about to push me over the edge of sanity.

"Please don't hurt me!" I cried.

"Bitch, did you hear me? Get on your knees!"

Just then, I looked into his eyes. The eyes were so familiar, I had to regroup to be sure I didn't recognize the man. On the surface, I realized I had never seen him before. But, the deeper into his eyes I looked, I recognized the demon that had chased and tortured me over the years. Through Floyd. Through the juvenile drug dealer. Through Aunt Rita. Through Derek. Through Jerome. And even through my own mother. This entity of destruction, had used almost every person in my life to attempt to destroy me.

I was sodomized in broad daylight, with a gun to my head and no one to help me, but God. I prayed that my life wouldn't end. Then, after my assailant was satisfied, he disappeared almost as suddenly as he came.

I realized that day that I wasn't born into bad luck. I wasn't a victim of circumstance or in the wrong place at the wrong time. I had seem "him" all my life, but I simply refused to believe that there was anything supernatural taking place.

"Papa", was more than just a figment of my imagination. He was real and he was after my life.

Chapter Fourteen
The Delivered Piece
(Anna)

The love for my husband and children could not be measured. However, raising a family in my mental state became more and more difficult. There were days when I contemplated killing everyone, including myself. I knew that the demons I battled added fuel to an already futile situation. As much as I tried to resist the urge to listen to the voices, I still couldn't tell anyone about, the demons. Who would believe me? I barely believed myself.

My mind was spiraling out of control and it didn't help that my body was reacting even worse. I thought that there was no way that life could become any worse for me, until the doctor's visit that changed everything.

"Hello Anna."

"Dr. Sullivan."

"How are you feeling overall today?" He asked, jotting notes in my file as he talked.

"Well, I have pain that I can't explain and I don't know how to make it stop." I told him matter of factly.

"Mrs. Johnson, according to your test results, you've been diagnosed with a very rare form of Oral Cancer." He paused long enough to gage my reaction.

"Oral Cancer?"

"Ma'am, I'm so sorry to have to tell you this, but it appears to be Stage 3. I have to be honest, because of the rarity of your diagnosis, any treatment would be completely experimental. I wouldn't be able to tell you how the treatments will affect your illness. There's no way to surgically remove the Cancer, we can only hope to reduce the size of the tumors." He explained.

Still in a daze and full of disbelief, I tried to comprehend the news I had been given.

"So, you're telling me that these knots in my mouth are Cancer?" I needed clarity.

"Yes ma'am. I'm so sorry."

Being constantly sabotaged in the past, by my mother, had caused me to be reluctant to bring anyone to my doctor's appointments; including my husband. As unfair as it may have seemed to Jermaine, it was yet another way to give me the peace of mind I needed. But I needed him that day.

The ride home from the doctor's office seemed to be the longest I had ever encountered. It was like the car drove itself. I don't remember the street lights, the turns, or the landmarks. It's a wonder I made it home in one piece.

For the days to follow, I was even more withdrawn than normal. I couldn't think. I couldn't sleep. Plus, I was in too much pain to eat. Although Jermaine noticed immediately that something was wrong, he tried to give me the time and space to let him know exactly what that something was.

I had lived with HPV for several years, but the news that Cancer was spreading through my body, felt like a death sentence. I wasn't quite sure how to reveal this to my family. At one point, I felt if I just died in my sleep, then they wouldn't have to see me suffer. I actually wished for death.

My mental behavior had caused me to be banned from my former church home, so I even felt like I had no one to pray for me. I was lost and defeated.

"Baby, what's goin' on witchu?" Jermaine asked, as he sat next to me in the bed.

I couldn't fake a smile if I tried, but I put forth my best effort to pretend everything was alright.

"Whatchu mean?"

"I mean, you been acting strange since Tuesday." He said.

I looked into his eyes and took the deepest breath I could muster.

"Dr. Sullivan told me the knots in my mouth are Cancer and he's not sure what can be done to help." I blurted out.

The look in his eyes made me instantly regret my delivery, in hindsight, it was a tad insensitive.

We talked, we cried, we prayed, and then we made the decision to go with the traditional treatments. Not wanting to prematurely upset the children, we waited until it was obvious, due to treatment, that something was different. I hid the pain and suffering to the best of my ability, but my physical appearance left nothing to the imagination.

I was losing weight faster than I could ingest a meal. And I was losing hair over every inch of my body. In fact, everyone seemed to notice my deterioration, except for Mother.

Well, it wasn't long before I found out that my mother didn't notice, not because she wasn't paying attention, but because she didn't want to notice. Either way, I felt as my mother, she at least deserved to know.

"Mother, I need to talk to you." I held the phone to my ear and prepared to share my diagnosis.

"What is it, Anna?" She almost sounded like she had authentic concern.

"I've been diagnosed with Cancer." I told her.

"Cancer? What kind of Cancer?"

"Oral Cancer."

"So, this just came out of the blue? Are you getting treatment?" She asked.

"Out of the blue?" I was irritated, but I decided to ignore her statement. "Yes, I'm getting radiation and I'm taking a pill form of Chemo."

"Mmmm. Has Jermaine been to the doctor with you?"

"Why, Mother?" I couldn't understand the reason for her questions.

"Because I'm having a hard time believing this. You didn't look sick the last time I saw you."

"Mother, goodbye."

I hung up the phone before she could say another word.

That day, I made the decision that I would no longer be controlled emotionally or psychologically by my mother. I would no longer allow her to dictate my emotions and manipulate my self-esteem.

I realized that no matter how much I loved her, or tried to be accepted, that she would never do right by me until she came to terms with her own issues: rejection, hurt, low self-image. She was projecting all of these things onto me. But coupled with her greed, these things turned her into the abusive, manipulative, untrustworthy person that had contributed to the damage in my life.

I needed something bigger than myself. I needed to be around people that loved me, more importantly, God.

After a rocky few years, I'd developed a relationship with Jermaine's sister, Vivian. My mistrust for people in general, created a gap between us that was eventually bridged over the years.

I would confide in her about my mental illness and my issues in my relationship with her brother. So, I felt it only fitting that I talk to her about my Cancer diagnosis. As always, she was understanding. But she extended an invite that would literally change my life.

"You should come to the Victory Empowerment Session." Vivian said.

"The Victory what? What's that?" I asked.

"I'm in a mentorship program called Christian Women Walking in Victory, and we're having a Victory Empowerment Session this weekend."

I was reluctant at first, due to the judgement of people in the church. But for some reason I was compelled to go, reservations and all.

Victory Empowerment Session

It seemed that everything that could go wrong in my mind, did. I was apprehensive about going the Empowerment Session. My paranoia had me convinced that everything that could go wrong, would. But despite my many apprehensions, something inside me forced me to attend.

Upon arrival, I felt like a spectacle. It seemed like everyone was looking at me and whispering to one another. Vivian, noticed my discomfort and decided to introduce me to the CWWIV members.

As friendly and polite as everyone was, the hugging and touching caused me anxiety all over again. I retreated to the outside to smoke a much unneeded cigarette. I was nervous and shaking, but even I couldn't understand why is was anxious to that degree.

"Anna, there you are. Service is about to start." Vivian announced.

I put out my cigarette and I reluctantly returned inside.

"Let's just praise God and usher in the Holy Spirit." The Minister said, beginning the service.

A powerful prayer ensued, and the rest is history.

The details of the next thirty-minutes to an hour are sketchy. But the ladies recollection of the events were astonishing. According to Vivian and several others, once I fought the urge to run out of the building, I finally went up for prayer. The last thing I clearly remembered was the feeling that came over me at the thought of being touched by so many hands. I was close to a breakdown, before the purge.

When I allowed the women to place their hands on my head, chest, and stomach, and anoint me with oil, I lost total control of the situation. I felt like I was being cleansed from the inside out for the first time in my life.

Afterward, I could only remember pieces of the event. I was told that once I surrendered my will, my body released a blood-curdling cry. I convulsed. I threw up. I screamed. But most importantly, I was delivered.

When I regained complete consciousness, my soul was changed. It didn't even matter that I had been diagnosed with Cancer. The only thing that mattered at that moment was the silence. The voices were gone for the first time since they appeared. I immediately felt and looked different than when I came.

For the first time, I didn't feel I was being judged. I wasn't being used. I wasn't being manipulated. And, if I had not just felt the hand of God, I felt his love through those women that genuinely cared for and loved me, without wanting anything but the best for me in return.

I was no longer, Nikki, or NuNu, or James, or the four-year-old girl that lived in my head. I was Anna, finally . . . I was just me.

Chapter Fifteen
The Peace

"Today, the pieces of my life are slowly coming together. Thanks to God leading me to Christian Women Walking in Victory, through Vivian. It's amazing how Satan will manipulate you by using his influence to change your life. I'm just elated that God's influence is stronger.

I have overcome so much in my life: rape, molestation, physical abuse, emotional abuse, prostitution, mental illness, terminal physical illness, and demonic possession. But I have heard God's voice clearly and I know that none of my life has been in vain.

My mother remains in denial about the abuse, as well as, other events in my life. Her attempt at an apology after I hung up on her, made me feel we were taking steps in the right direction. But the fact that her apology was for "what I think I went through", made it null and void, therefore, completely irrelevant. Meanwhile, Aunt Rita has actually admitted to her hand in abusing me, and has given a sincere apology for her actions. I can't imagine anything but God being the reason for her change of heart.

Although Floyd has never admitted to what he did, to my knowledge, other family members have come forward admitting to turning a blind eye to the abuse and neglect. However, Leah and I, still have a strained and somewhat distant relationship. Torie and I, however, are still very close. And even thought she was young at the time, she has been able to validate a lot of the memories that I've suppressed over the years.

There has even been slight closure concerning Derek. While Drake and I have a distant relationship, I still stay connected to Samuel. As my fears were confirmed, so were my suspicions, when Sam told me about a conversation between him and his father concerning the incident that happened between us."

"Anna, I was really sad and confused when you stopped coming around." Samuel told me at a family picnic.

"I know Sam. But things were complicated. I just want to apologize for not being there for you when your mom passed. And I can't apologize enough for the part I played in tearing your family apart."

He looked down at the table for what seemed like forever, and then he spoke.

"I talked to my dad . . .it wasn't your fault."

His statement almost knocked me out of my seat.

"Wh . . . What did he say?" I had to know.

I had waited for almost twenty years to find out what would make the man I saw as my father, violate me the way he did. I always needed to know if it was my fault.

"He said he doesn't know what happened. He told me that one minute you all were talking, and then he's not sure what came over him. But, he remembers that he wasn't in control. He couldn't stop himself. He said, it was like he was watching it all happen, but there was nothing he could do."

"Sam hadn't realized it, but he confirmed so much for me that day. Now that I am delivered from the voices, I realize that the demons were not a figment of my imagination. The possessed look in Derek's eyes, was real. The reality is, all the demons that had exposed themselves to me over my life, were as real as you and me.

The clarity that has come with my deliverance is astonishing! It feels so good to be accountable for my own actions for once in my life. That clarity, has allowed me to be more tolerant and accepting of my husband and children's actions, or lack thereof. I am learning to operate in the Fruits of the Spirit of God.

There are issues that may never resolve themselves, in this life. But I have learned to trust in God and give it all over to him. Trust me, it's been a long road to discovering that the reason for the tragedy in my life is much bigger than me. Bigger than my pain.

I've seen true miracles and I have no doubt that Jesus is the true and living God. Chelsey, is a healthy and happy teenager. With our faith in God, she has defied all odds and her health battles are behind us. There have been several occasions over the years where doctors told me that my daughter's time on this earth was limited. But God!

My struggle with finding her father, is no longer a struggle. Along with our Heavenly Father, Chelsey has all the dad she needs in Jermaine. I thank God for him.

But, God was not done performing wonders. His miracles didn't end with Chelsey. In the midst of all my physical pain and suffering, I held strong in my faith that his will for my life be done. The doctor's prognosis wasn't good and my reaction baffled him."

"So, what's the verdict, Doc?" I asked, making light of the situation.

"Well Anna, to be honest, there's not much more we can do. Your test results show no improvement at this point. My suggestion is that we admit you and start an aggressive radiation therapy, coupled with your Chemo." Dr. Sullivan explained.

I sat in silence. I'm not sure how much time passed, but after my stomach began to settle, I responded.

"No."

"Excuse me?"

"No. I'm not staying. I'm not doing the aggressive radiation. You're gonna kill me."

I proceeded to gather my belongings and exit his office.

"But Mrs. Johnson . . ."

"I'll sign whatever release you need me to, but I'm not staying."

"Something about my final response let the doctor know that I meant what I said. I left the office that day, in pain, but with faith that God's perfect will would be done. Mentally and spiritually, I was prepared for whatever my fate had to be. My only concern was for my husband and children.

Continuing to fast and pray, with the help of a few people I trust, I slowly began to see a change in my health. My hair began to grow back, I gained weight, and my pain had been minimized to minor discomfort."

As I sat in my doctor's office for routine bloodwork results, I received another invite from Vivian, to attend another Victory Empowerment Session. Just the thought of fellowshipping with such spiritually powerful women, quickened my spirit. My doctor entered the room at almost the same time I was hanging up my phone.

"Anna . . . um." Dr. Sullivan studied the file in his hand with puzzlement. "How do you feel?"

"I feel much better, actually. Doc, talk to me." I urged him.

"Well . . . your bloodwork, it's . . . you seem to be in remission." He sounded confused as he spoke.

"That's a good thing, right?" I was puzzled by his reaction.

"It's so rare that someone recovers without treatment of some kind." He told me.

"Oh, I still got treatment. I just relied on another doctor, that's all."

"You saw another oncologist?" He asked.

I chuckled to myself at the oblivion on his face.

"I was talking about God. All I've done is pray, and put as much natural elements in my body as possible."

"Well, I want to suggest that you come back in a couple of weeks; you know, just to be sure."

"Of course. I'll come back, but God doesn't make mistakes, Dr. Sullivan."

"I went back, and of course the results were the same. I had no doubt in my mind that my faith in God would make me whole, and it did. I had literally felt the power of God in my life.

During that time, I developed a true relationship with God. Becoming a part of Christian Women Walking in Victory, was the catalyst I needed to get me on the right path.

Once I began to get to know the women that helped to usher out the demons that sought to kill me, I realize how truly anointed they are. They walk in victory with the Lord, and that inspires me. I went through a twenty-four week program, and I grew closer to my Savior with every assignment. I love my CWWIV mentors. They are still a part of my family.

Even though this is only part of my story, I've never revealed this much about myself to others without breaking down. In fact, I feel strengthened and liberated. I can tell by the emotion filled room that I have your empathy. But I beg you, please don't feel sorry for me. Because I wouldn't be who I am today if not for all that I've gone through.

God knows me better than I know myself. Sometimes if not for the struggle, we wouldn't appreciate the most important things about this life. That's why I feel wholeheartedly that my struggle has been to crucify my flesh, and to bring someone else out of their rejection, to draw closer to the Kingdom.

Finally, I understand what has happened to me all those years ago. I was about to engage in a conversation with my Lord and Savior when he stopped me and asked me a very serious question."

"Who I am to you?" He asked.

I said. "What, you know you are THE GREAT I AM, THE KING OF KINGS, MY LORD AND SAVIOR, THE CHRIST . . ." And the list went on and on.

Finally the Lord said, "STOP! WHO AM I FOR YOU?"

I didn't fully understand the question, but I felt the Holy Spirit moving through me like I was about to faint, but I didn't.

"I don't know Lord. What would you have me call you?"

What followed, could have, should have, caused me to drop dead right there. Then my Lord Jesus spoke INTO me and said,

"I AM A MAN OF MANY SORROWS."

"Tears began to fall from my eyes; big ones. But I couldn't make a sound. Something inside of me was about to burst. I started to shake with little tremors but it felt wonderful, and then I started to see what he meant.

We've have taken Christ's sacrifice for granted, not truly having the full understanding of what it meant for Jesus to take on all the sins of the world onto himself. I was in a full relationship with Satan. I ate with him, watched TV with him, slept in his bed, and had sexual relations with him; even orgies with his minions.

I know firsthand what it's like to dwell in hell. To be face-to-face with the darkness. But I survived it. HOW? When Jesus was crucified he had to descend to hell to rescue me! The devil was making all of us his personal concubines and runners to do his bidding whenever he wants."

The Lord spoke again and said, "The ones I choose, he treats the worse; look Anna."

"I look and I see me being raped over and over again by all types of demons, while being beaten at the same time. I was bloody all over and I just kept crying out for God to please help me. Please make it stop. And every time I did; he did. Jesus placed himself inside of me literally and wept with me, while protecting me. You see, the demons had my body, but not my soul. Only because Christ had replaced my soul with his so that I would be protected where it counts, despite the physical and emotional pain. Anna, died a long time ago and my God had to place something inside this empty vessel, and he chose himself.

Did you get it yet? Do you feel it? GLORY TO THE ALMIGHTY GOD! In the Bible, Jesus wept because his friend Lazarus died in his absence. Jesus knew what he was going to do. He knew it was nothing for him to raise his friend from the dead. How much did it take out of him to keep losing pieces of himself; his virtue? The woman touched his garment and he instantly felt something leave him. The more sin he took, the more disconnect he felt with his Father in Heaven. This is the true reason Jesus wept. He wept for me, with me; he took all of the things I took. He does this for all his children.

My outlook changed at that very moment. I was seeing things for the first time again, with new eyes. This was more than just being a new generation Job. This was Jesus allowing me to feel all of what he felt. To die and be resurrected so that I will dwell in the house of the Lord forever and ever. God chose me, so he needed me to hate everything about this world, so that I would reject everything in it. He allowed me to feel like an outcast, because I am one. He was performing surgery on me this entire time, almost like remaking mankind. The devil was trying to use what God allowed him to do, to trick me into thinking that no one on this earth would ever want or truly love me. But whenever things got tough for me, God would hide me.

The truth is, he misses God and he knew that God would come for me. The devil uses any excuse to be in the presence of God and we are God's weakness. A good parent cannot just stand around while their child or children are being mistreated. I was a pawn in a game as old as time. Jesus used the Devil's blind destruction to resurrect me for the Glory of God.

Jesus said, 'Children all over the world will glorify my name and know my name through my resurrection in you, Anna.' The anger that I thought was already gone was leaving me, I began to feel strength like I never had before. I was being possessed again, but this time with The Holy Spirit, and it will stay and dwell in me for eternity.

I am forever changed, all things are different for me now. I am able to love those that hurt me and truly forgive those that have not given an apology. It's like starving and finally someone feeds you. Now God is helping me to connect my heart with my mind so that I can forever hate my worldly nature, but not the will of God. I take nothing for granted. When I can eat, drink, laugh, smile, speak, love, move my fingers and toes. It all means so much more to me. I am in utter amazement at how much my Father loves me.

I thank him every moment, for every day, for his Grace and Mercy in my life. Now, when I think about what I've been through, I can only see God. I no longer dwell on the horrific acts of abuse, but the rescue and the protection that was bestowed IN ME, by CHRIST. I can hold my head up high and be proud to say . . . I AM REDEEMED. BOUGHT WITH A PRICE. JESUS HAS SAVED MY WHOLE LIFE AND HE HAS RISEN AGAIN. Amen."